T0278312

SECRET DORCHESTER & AROUND

Andrew Jackson

AMBERLEY

First published 2023

Amberley Publishing
The Hill, Stroud
Gloucestershire, GL5 4EP

www.amberley-books.com

Copyright © Andrew Jackson, 2023

The right of Andrew Jackson to be identified as the
Author of this work has been asserted in accordance
with the Copyrights, Designs and Patents Act 1988.

ISBN 978 1 3981 1255 1 (print)
ISBN 978 1 3981 1256 8 (ebook)

British Library Cataloguing in Publication Data.
A catalogue record for this book is available from the
British Library.

Typesetting by SJmagic DESIGN SERVICES, India.
Printed in Great Britain.

Contents

Introduction

Dorchester is situated centrally in Dorset and throughout its 6,000 years, has experienced a fascinating history.

In the Neolithic, Bronze and Iron ages the area was populated by the powerful Celtic Durotriges tribe, who were subsequently subjugated by the Romans, who in turn created the fortified town of Durnovaria which became an important market town for the surrounding countryside.

When the Roman Empire went into decline and the legions departed, the town diminished in stature and the area became dominated by the new Saxon invaders, who referred to the town as Dornwaracester and themselves as Dorsetas. 'Dor' came from the original Celtic language and 'cester' was an Old English/Saxon word for a Roman fortification.

The fortunes of the town underwent a revival during the medieval period, when it became involved in the weaving and dying of wool, which led to the town receiving a royal charter and becoming the county town in 1305.

In the seventeenth century, prior to the English Civil War, Dorchester became a major centre for Puritanism and subsequently supported Cromwell's Parliamentarians during the ensuing conflict. However, despite the intensification of fortifications, particularly at Maumbury Rings, the Royalists captured and plundered the town in 1643.

The Royalist Cavalier soldiers were then moved on to fight elsewhere, but upon their later return they were forced to retreat by the Dorchester Puritan defenders.

Dorset has been the stage for various historical events over the years, not least of which was the Monmouth Rebellion of 1685, which started at Lyme Regis and subsequently saw the county pay a horrifyingly heavy price, as the feared and loathed Judge Jeffreys wrought shocking and violent retribution. The Bloody Assizes took place throughout the West Country, but at Dorchester, the esteemed judge seemed to be in a particularly vindictive mood. So much so, that although people of Dorchester generally may not have a great awareness of the Monmouth Rebellion, the mere mention of the name Judge Jeffreys is enough to send a shiver down the spine of most local residents.

In the seventeenth and eighteenth centuries Dorchester suffered several serious fires, the worst of which was the fire of 1613, in which many of Dorchester's oldest buildings were destroyed including All Saints and Holy Trinity churches. The only early buildings of note that did survive were Judge Jeffreys' Lodgings and the Tudor Almshouse, Nappers

Mite. Most of the burnt-out structures were subsequently replaced with Georgian buildings made from Portland stone, a fine example of which is Shire Hall.

In the eighteenth century, Dorchester's wool industry began to decline and eventually ceased altogether due to increased competition from Yorkshire woollen towns, and instead the brewing industry came to the fore, with the advent of the now deceased Eldridge Pope Brewery.

Nobody captured the essence of Dorset's rural heritage better than Dorchester's favourite son, Victorian novelist Thomas Hardy, whose tales also captured the rhythm and character of the surrounding pastoral countryside, which has ever since been known as 'Hardy Country'. He also brought to life the harsh privations of the Dorset farm labourer, which were all too apparent as stark reality in the appalling plight of the Tolpuddle Martyrs.

Hardy wrote some masterpieces of English Literature, with *Tess of the D'Urbervilles* and *Far from the Madding Crowd* among his most revered. However, arguably his best and most famous novel is *The Mayor of Casterbridge* – Casterbridge being Hardy's fictional name for Dorchester – in which he draws upon his intimate personal knowledge of the town to create an absolute literary classic.

Although Dorchester is now no longer the rural backwater it was in Hardy's day, it still retains its quintessential charm and Hardy would still recognise many aspects of the place and no doubt still feel very much at home in his native environs.

1. Ancient Man – The Celtic Durotriges Tribe

In the Neolithic period (9000–3000 BC) through the Bronze Age (4000–2000 BC) to the Iron Age (1200–600 BC) and the Roman invasion (AD 43), England consisted of numerous disparate indigenous Celtic tribes, and the powerful Durotriges lived in what is now Dorset, South Wiltshire, South Somerset and East Devon.

Dorchester was considered to be the capital of the region and consequently the town and the surrounding area boasts an amazing array of ancient sites.

Within the boundaries of the town are six ancient sites, including Maiden Castle, the largest hill fort in Britain. Also, the South Dorset Ridgeway is nearby, which is an area of a particularly rich abundance of ancient sites, considered to be of an international archaeological importance on a par with Stonehenge.

Ancient Sites Within Dorchester

Henges

By the Bronze Age, barrows, cursuses and other enclosures had ceased to be constructed, and instead circular monuments of various types tended to be built, such as henges and stone circles.

Henges are circular banks with ditches inside them that may contain stone structures; for example Stonehenge. They are considered to be ancient ceremonial sites dating from the Bronze Age. Some henges consisted of stone or timber circles.

Maumbury Rings

Maumbury Rings is a Neolithic henge on the south side of Dorchester. It was excavated in the early twentieth century by a team led by the archaeologist Harold St George Gray, to reveal a henge originally constructed at least 4,500 years ago.

Archaeologists revealed eight pits, the sides of which were made of solid chalk. Also contained within were human and deer skulls dated between 3000 and 2000 BC. Antler picks and shovels were also found at the site, which are believed to be the tools used in its construction.

They identified the main entrance as being in the north, where there may have originally been a large standing stone.

DID YOU KNOW?
The name Maumbury is thought to have come from the Old English word *maum*, meaning chalky soil, and *bury*, an Old English word meaning earthwork or fortified town.

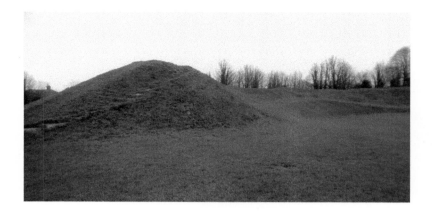

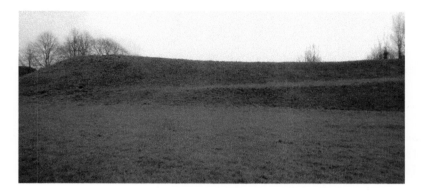

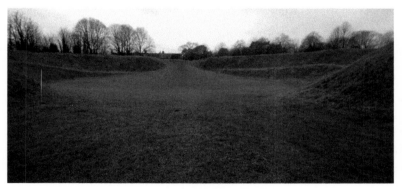

Maumbury Rings.

Dorchester Henge

Dorchester Henge was discovered in 1984 during archaeological excavations beneath Acland Road and the surrounding area prior to the building of Waitrose. The henge was built over 5,000 years ago and consisted of a circle of 500 to 600 enormous timber posts, covering an area large enough to accommodate ten football pitches. Its vast scale is thought to indicate that it must have been of considerable importance to the Durotriges.

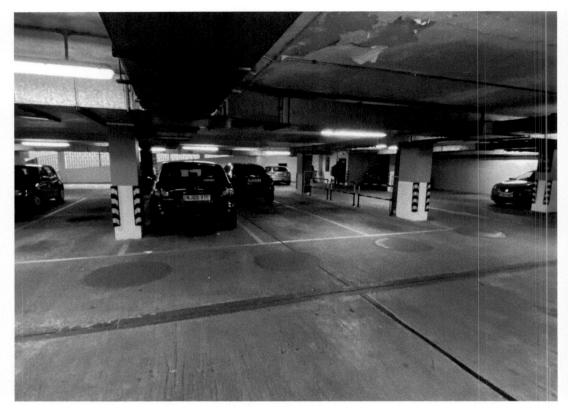

Dorchester Henge. The basement floor of Waitrose's multi-storey car park is at the site of what was Dorchester Henge. The large red discs on the ground mark the position of some of the 500–600 wooden posts that made up the immense circular monument that was built over 5,000 years ago.

Barrows

Various types of barrows are found throughout Dorset, including long barrows, round barrows, bank barrows, bowl barrows, bell barrows, disc barrows and pond barrows. They are thought to be ancient burial mounds. They often occupy prominent positions where they can be seen from a distance, and in many cases are clustered around other ancient sites.

Long barrows tended to be built during the Early and Middle Neolithic periods, and were constructed of earth or dry stone mounds with ditches. They are among the earliest type of ancient monument readily seen.

Mount Pleasant/Conquer Barrow

Mount Pleasant on the outskirts of south-east Dorchester is a probable Neolithic henge and barrow. It was discovered by Stuart Piggott in 1936 and has been largely ploughed out except in its southern arc.

Further archaeological inspection in 1969 identified entrances to the henge and a smaller henge within the main oval-shaped enclosure.

It is considered to be the best example of a henge in the area of Dorchester and the South Dorset Ridgeway and is a large 'super henge' structure similar to Durrington Walls and Avebury in Wiltshire and Knowlton in Dorset.

Interrupted Ditch Enclosures
Interrupted ditch enclosures are single or multiple concentric circles of ditches which are interrupted by sections of earth.

Flagstones
An example of an interrupted ditch enclosure can be found near Thomas Hardy's former abode, Max Gate. The enclosure has been named Flagstones as it was discovered at the site of Flagstones House, which was demolished in 1987 to make way for the Dorchester by-pass. The remaining part of the enclosure is still under the grounds of Max Gate.

The Bronze Age enclosure is thought to have consisted of a circular ring of unevenly spaced pits and causeways dug into the chalk.

At the bottom of the pits the remains of an adult and two children were found, each beneath a separate sarsen stone. A young man was also found buried in a Bronze Age tumulus in the middle of the enclosure and Neolithic carvings were found on the walls of some of the pits.

Thomas Hardy was unwittingly involved in the excavation of Flagstones, when in 1891 workmen discovered a 3-foot sarsen stone under his garden at Max Gate surrounded by charred bones. It was only the subsequent discovery of the Flagstones enclosure that enabled archaeologists to realise Hardy's find was part of the enclosure.

DID YOU KNOW?
Hardy must have had some inkling of the significance of the stone as he referred to it as the Druid Stone and had it erected at the edge of the lawn where it still stands.

Hill Forts
Hill forts are typically of the Bronze or Iron Age and are found throughout the Celtic regions of Central and Western Europe.

It is believed that the Durotriges tribes generally lived in a peaceful, orderly fashion, but their lands were protected from neighbouring tribes and invaders by a string of hill forts.

Maiden Castle
Maiden Castle, on the south-west fringes of Dorchester, is the largest and most spectacular Iron Age hill fort in Britain.

It is thought, from a study of the artifacts found in the vicinity, that it was first occupied around 2000 BC, before fortifications were added around 3000 BC. The scale of the

Maiden Castle from the distance.

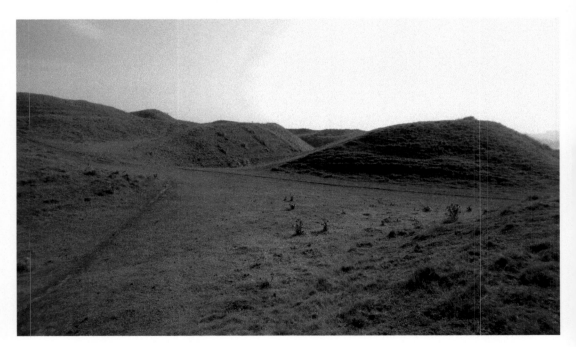

Above and opposite: Maiden Castle.

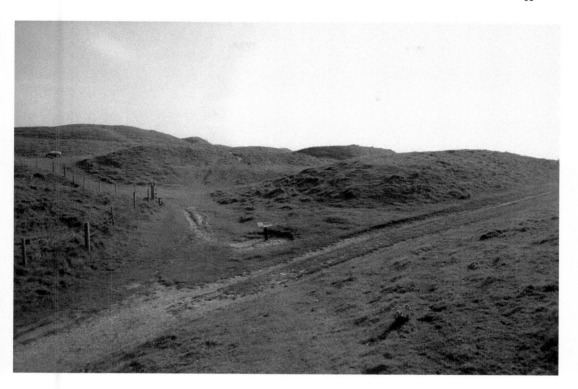

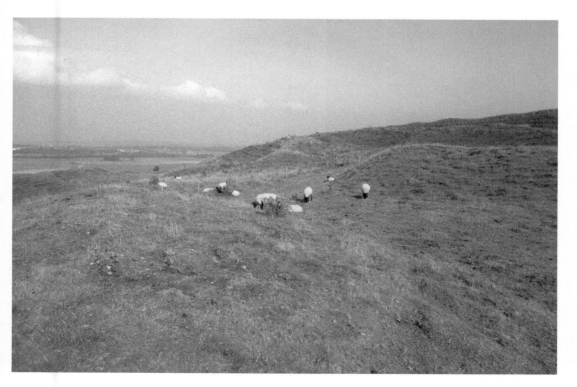

defences were gradually increased over a timescale of around 3,000 years and eventually contained numerous ramparts, some of which are as high as 80 feet and covered an area equivalent to fifty football pitches.

The inhabitants at the fort's peak in the Middle Iron Age were several hundred in number.

The entrances were well protected with timber, earth and stone and any attackers trying to invade the complex would have to have approached through a long twisting path, making themselves vulnerable to attack.

Shallow, oval graves were found at the site, with the bodies laid in crouched positions and with a last meal placed beside them.

Poundbury Hill Fort
Poundbury Hill Fort was an Iron Age fort situated on a ridge to the north-west of Dorchester that had commanding views over the River Frome. The area remained in the hands of the Durotriges until like Maiden Castle, it too was taken over by the Romans.

There is evidence of a Neolithic settlement as well as late Iron Age burials. A cemetery on the north-eastern side was discovered and excavated in the 1970s and was found to consist of some bodies dating to the Late Neolithic period. However, the vast majority were from late Roman times of around the fourth century.

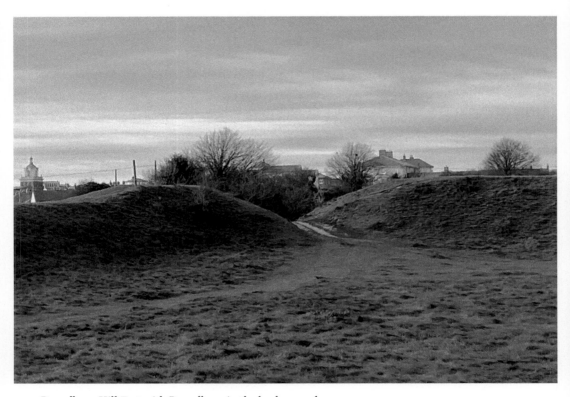

Poundbury Hill Fort with Poundbury in the background.

Ancient Sites – South Dorset Ridgeway

Valley of Stones

The Valley of Stones is situated near to the village of Little Bredy and is in the vicinity of the majority of Dorset's stone circles on the South Dorset Ridgeway. Therefore, experts have concluded that it seems highly likely that the sarsen stones, formed here during the Ice Age, were used in these structures.

Stone Circles

The purpose of stone circles is shrouded in mystery, although it has been postulated that they were used for some sort of ancient ritual, possibly connected with burial ceremonies. Another theory is that the stones are specifically aligned for astronomical purposes, and worship of the sun, moon and stars. Similarities can be drawn with Stonehenge in this respect. Yet another theory is that the presence of the stones was used to confer status and power upon the residents.

Stone circles are prevalent throughout much of Britain, Ireland and Brittany, and are thought to be from the Late Neolithic and Early Bronze Age.

There are nine stone circles in Dorset and they have a tendency to be smaller than those elsewhere. They tend to be made of sarsen stone, apart from the Rempstone stone circle which is made from local sandstone. Rempstone is also the only one not located on the chalk hills south-west of Dorchester.

Nine Stones, Winterbourne Abbas

The most important stone circle in the area is considered to be the Nine Stones at Winterbourne Abbas. The stone circle consists of nine irregularly spaced stones, two of which are significantly larger than the others, which is an arrangement inconsistent with other stone circles in Dorset.

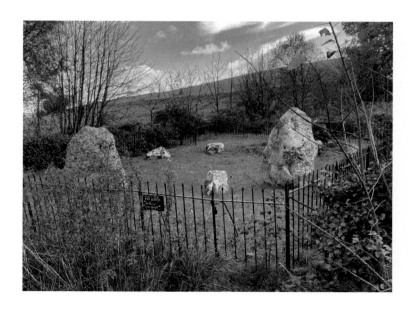

Nine Stones,
Winterbourne Abbas.

Hampton Down Stone Circle

The Hampton Down stone circle lies on the South Dorset Ridgeway in the hills above the village of Portesham, overlooking the English Channel.

The site was excavated in 1908 and at that time it consisted of sixteen stones; however, the archaeologists involved in the excavation came to the conclusion that the stones were not in the correct place and accordingly moved ten of the sarsen stones slightly to the west.

The circle is relatively small with a diameter of only 20 feet and it is believed to have been constructed during the Bronze Age.

Kingston Russell Stone Circle (also known as the Gorwell Circle)

Kingston Russell stone circle, near Abbotsbury, is the largest surviving stone circle in Dorset. The ring consists of eighteen stones arranged in an oval shape, and is believed to be from the Bronze Age. The site has never been excavated.

Dolmens

A dolmen usually consists of a large flat capstone laid on top of upright stones. They are believed to date from the Neolithic period and are thought to be tombs that commemorate the dead and possibly were used as ceremonial sites.

Hell Stone

The Hell Stone is a dolmen on Portesham Hill, which was badly rearranged in an attempt to restore it in 1866. It is thought to date from Neolithic times and was used as a shepherd's shelter in the nineteenth century.

Grey Mare and Her Colts

The Grey Mare and Her Colts is a dolmen located near Abbotsbury. The structure is believed to date from the Early and Middle Neolithic period.

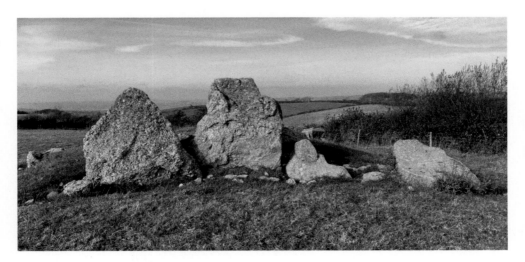

The Grey Mare and her Colts.

It was excavated in the nineteenth century and human remains were found along with pottery fragments. The slab lying on the ground behind the standing stones is believed to be the collapsed capstone.

Round Barrow Cemeteries

Round barrow cemeteries are thought to date to the Bronze Age. They tend to comprise of groups of up to thirty barrows of different types. They occur throughout Britain, but are particularly prevalent in the South Dorset Ridgeway area, and are often in prominent locations.

Winterbourne Abbas Poor Lot Barrow Cemetery

This site, which is unusual in that it is situated in a valley, as opposed to a more prominent location, consists of forty-four barrows of differing types. The largest barrow is a bowl barrow in the centre of the group.

Hill Forts

Abbotsbury Hill Fort/Castle

Abbotsbury Hill Fort commands a strategic position with views over the surrounding countryside in all directions, as well as over the sea, thus making it an ideal location to spot potential invaders.

The basic construction of the fortification would have consisted of a single ditch surrounded by two ramparts. However, the defences are more formidable at the south-eastern end, where there are four ramparts.

The Romans seized the fort before moving on to the bigger prize of Maiden Castle and it is postulated that little resistance was offered at Abbotsbury, as there is little evidence to suggest a violent struggle. However, the fort has never been properly excavated to confirm this.

2. The Romans – Durnovaria

In AD 43, the Emperor of Rome dispatched a Roman army to conquer Britain and the Roman soldiers that arrived in the Dorchester area in AD 43/44 were of the 2nd Augustan Legion who had been given the task of defeating the Celtic Durotriges tribe.

They were under the command of Emperor Vespasian, who later became Emperor of Rome, and by AD 70 they had subjugated the Durotriges and established a formidable garrison which they called Durnovaria.

The Battle of Maiden Castle, AD 43

Maiden Castle on the outskirts of Dorchester was the major stronghold of the Durotriges tribe and it provided effective protection against rival tribes. However, in the first century AD, the resident Celtic Durotriges encountered an entirely different proposition in the form of the mighty Roman army, as the opposing factions became embroiled in the earliest conflict of note in Dorset: the Battle of Maiden Castle.

Mortimer Wheeler and his wife, Tess, excavated the site in the 1930s and were able to painstakingly piece together the history of the fort. They suggested that the Durotriges were overwhelmed after a fierce battle by the superior power and discipline of the Roman army, despite the improvements the Durotriges had made to the castle in preparation for the attack.

The Wheelers uncovered numerous graves thought to be from the battle and one of the many finds at the site was a human vertebra with an iron spearhead thrust through it. Many of the skeletons found were thought to have had damage inflicted by sword or by missiles thrown by Roman ballistae (missile catapults). However, a later archaeological dig undertaken in 1985/86 by Neil Sharples established that the burial ground had been established some time before the Roman invasion and that a massacre was therefore unlikely.

Anyway, having dealt with the local opposition in whichever way, the Romans established their own garrison at the site, which in turn led to them building the basic infrastructure that became Durnovaria. The modern street plan of Dorchester still contains the original Roman influence.

Roman Walls

The defences that surrounded Durnovaria were built at the beginning of the second century AD at the command of the Governor Augustus. They originally consisted of three pairs of banks and ditches. The banks were 20 feet high and 8 feet wide.

It was 200 years later that the actual wall was constructed on top of the banks for increased security. The wall, which added a further 10 feet to the existing 20 feet of the earthen banks, consisted of an inner rubble core sandwiched between blocks, which

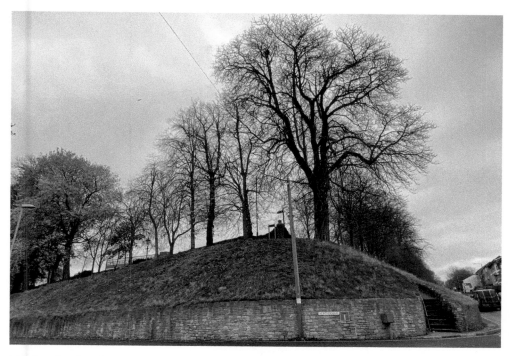

Northernhay by The Grove provides a good example of the protective banks on which the Roman walls were built.

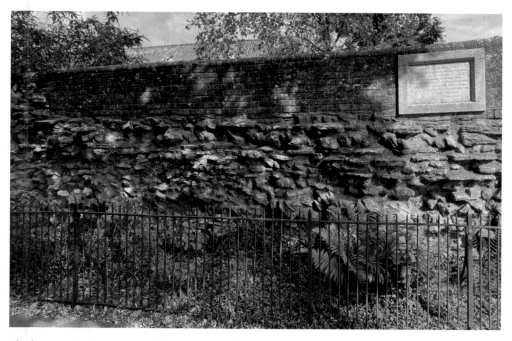

The last remaining section of the Roman wall can be seen in Albert Road.

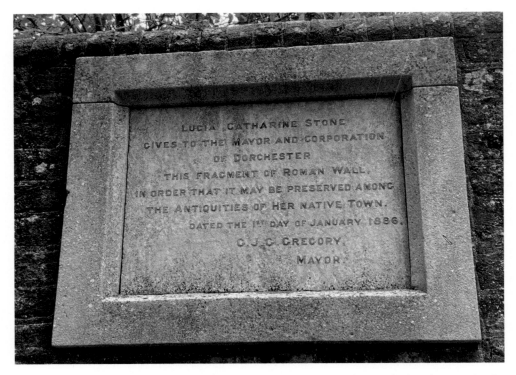

The section of Roman wall formed part of a property boundary and was gifted to the town by the owner, Lucia Stone.

would have been cut to shape with iron tools and cemented with a mixture of lime and water. The stone is thought to have been transported by oxen cart from the South Dorset Ridgeway.

Towards the end of the seventeenth century, the walls had fallen into disrepair and much of the stone had been taken for alternative usage, meaning that apart from a very small section of wall, only the earthen banks that the wall was mounted on can be seen today.

The only vestige of the original wall that remains in situ, near the Top O'Town roundabout, only survived because it was incorporated into a residential garden wall, and in 1886 it was given to the town by the owner of the property, Lucia Stone.

Archaeologists have also found evidence of an earlier wall but the extent of that is not known.

The Walks

Durnovaria's defences survived until the eighteenth century when the ditches were filled in and trees planted either sided of the path, to create boulevards that became known as 'The Walks'. They were similar to the sort of thing that were in vogue on the Continent at that time, particularly in Paris.

In actual fact, the walks, which follow the path of the old Roman wall, have helped to preserve the fundamental Roman nature of the town, and the town remained contained

within the walls until the arrival of the railway in the nineteenth century resulted in greater development and expansion.

Poundbury Hill Fort

The Romans took over the existing Neolithic hill fort at Poundbury and enlarged it as well as improving the defences by the addition of timber. Also two sections of a Roman aqueduct have been identified to the north-west of Poundbury Hill Fort.

Aqueduct

In 1900 an aqueduct that the Romans used to supply water to Durnovaria was discovered as a course cut through the chalk. The source is presumed to be from the River Frome near Frampton around 12 miles away and as we have already seen, it flowed into the town close to Poundbury Hill Fort, following the contours of the river. The water was enclosed in a channel with timber sides and a clay bed, with a covering of soil and grass to prevent contamination.

Roman Fountain

A symbolic Roman fountain on the corner of Somerleigh Road by the former County Hospital indicates where the Roman aqueduct brought the clean water into Durnovaria.

In 2000, before the County Hospital was redeveloped, the site was subject to extensive excavations undertaken by Wessex Archaeology. The remains of some Roman houses

This symbolic Roman fountain was erected in 2003 outside the old County Hospital on the corner of Somerleigh Road, to indicate where the Roman aqueduct brought clean water into Durnovaria.

were found complete with intricate mosaics. Workshops and agricultural buildings were also discovered and in addition, stone ovens and a hoard of coins were found amongst numerous other artefacts.

However, prior to these discoveries mosaic and tessellated floors were dug up in the same area in 1863 and then 100 years later, further mosaics and tessellated floors were identified.

Roman Baths

In 1978, a Roman baths was uncovered in Acland Street, which was believed to have been supplied with water from the nearby aqueduct. Unfortunately, the area was then covered by a car park and a day centre, but before that archaeologists discovered a bath house that was built of stone and was a place for Romans to socialise as well as wash and swim. Also numerous artefacts were found as well as remains of walls, water tanks, mosaics and hypocausts – the underfloor heating system the Romans used.

Amphitheatre

The Romans also converted the ancient site of Maumbury Rings into an amphitheatre capable of holding 10,000 spectators.

It is thought that the amphitheatre was used primarily for demonstrations of military prowess rather than for gladiatorial contests. It is also believed that there may well have been events involving wolves, wild boars and bears, all of which existed in Britain at this time. Historians also consider that a possible site for the Roman barracks was opposite the Maumbury Rings amphitheatre in what is now the market site.

Maumbury Rings was subsequently used in the Middle Ages for events such as cock fighting or bear baiting and then later became a Parliamentarian fort during the English Civil War.

The site is still capable of accommodating a crowd of 10,000 people and continues to be used in a similar way to how the Romans intended. However, instead of hosting events involving cruelty and blood lust, it now focuses on events such as fairs and outdoor theatre performances.

DID YOU KNOW?

Maumbury Rings is one of the largest amphitheatres in Britain but one of the smallest in the Roman Empire.

Roman Forum

The town pump took over from the aqueduct in providing the town's water supply and replaced a market cross in 1784.

It is thought that the Town Pump and Corn Exchange lie above what was the Roman Forum, which as in other Roman towns would have included a main public building for meeting rooms and assemblies as well as a public square which served as a market place.

At the Roman Forum, a town council of 100 men, known in Roman parlance as an 'Ordo' (meaning order rank or class in Latin), would meet to elect magistrates and organise the raising of taxes for the provision of public buildings and facilities.

The area now is still host to market stalls and was the main market site of the town until the nineteenth century.

DID YOU KNOW?

Thomas Hardy certainly recognised the Roman connection to the market, as he was known to have said that on market day Dorchester reminded him of old Rome.

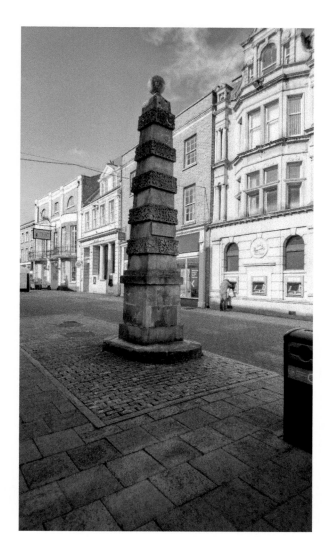

The town pump became the source of the water supply from 1784 and the old Roman forum is thought to lie beneath it.

The Roman forum is also thought to lie under the Corn Exchange.

Burial Sites

The Romans had a law that prohibited burial within the town's walls and this probably explains a burial site that was discovered in 1942 just below where the kiosk now stands in Borough Gardens, just outside the old Roman walls.

At that time fifty-two bodies were identified of both Romans and Celtic Durotriges, although it is also considered possible that many more skeletal remains of bodies may have been inadvertently destroyed when the park was levelled in the 1800s. A later restoration of the park in 2007 unearthed yet more bodies, which are believed to have been from a period later than Roman times.

Another site where hundreds of Roman and local Celtic bodies have been found is at what is now the Poundbury Industrial Estate. On this site, six of the bodies were encased in sarcophages, which were Roman coffins used to bury individuals of high status.

A plaque at the Roman Town House signifying the location of a child burial provides an interesting insight into the Roman psyche, as it seems that children were exempt from the burial outside the town law, as it is thought that the families would have wanted to have the child's grave close to them.

A sarcophage/Roman coffin.
On the site that is now the Poundbury Industrial Estate, hundreds of Celtic and Roman bodies were found including six high-status individuals encased in sarcophages.

Durngate Street was the main Roman road running through Durnovaria.

Artefacts

Many Roman artefacts have been unearthed over the years in Dorchester, and the County Museum boasts a good collection of these, including silver and copper coins known as Dorn pennies, a gold ring and a figure of the Roman God Mercury in bronze. A hoard of 32,000 third-century coins was also found in South Street in 1936.

The hill fort at Poundbury has also been a rich source of Roman artefacts including pottery and a cache of coins. Also, the area around the Roman Town House has yielded a Continental beaker, coins, bowls, handles for cabinets, broaches, jars, writing styluses (Roman pens), knives and tweezers.

The Roman Town House

Arguably Dorchester's finest Roman relic is the Roman Town House, which is the only example of such a building in Britain.

Dorset County Council acquired land at Colliton Park in 1933, with a view to building County Hall. However, before building commenced in 1937, archaeologists excavated the area and uncovered the remains of a first-century Roman house, complete with intricate mosaic floors.

The leading archaeologists in charge of the operation were Lieutenant Colonel CD Drew and KC Collingwood-Selby of Dorset County Museum, who also called upon the expertise of the eminent archaeologist Sir Mortimer Wheeler who was involved with an archaeological dig at Maiden Castle at the same time.

Between them, they uncovered seven buildings on the site, the most significant of which was the Roman Town House. They also found an astonishing amount of interesting artefacts.

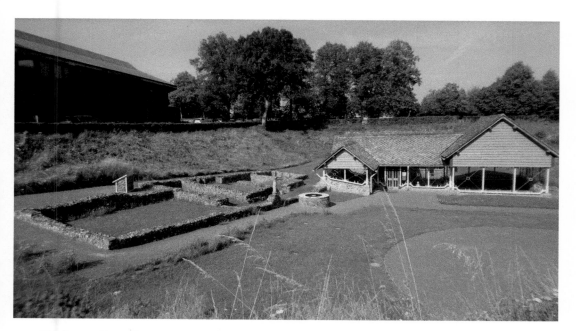

The Roman Town House.

They established that the Roman Town House was initially built in the late Roman period and was extended gradually over a period of a hundred years. It is also believed that the Roman Town House continued to be lived in for a short period after the Romans had left Dorchester in AD 410.

It is now imaginatively displayed, so that the general public can come and view the buildings free of charge. The site is constantly being worked on and during the 1990s a cover building in the style of the original was added, allowing the public to understand how the villa originally looked.

The intricate mosaics within the house were uncovered in the 1990s. It is believed that the mosaics were made from individual pieces known as tessevue and were sourced locally using stone and clay and then painstakingly laid out on the floor by hand.

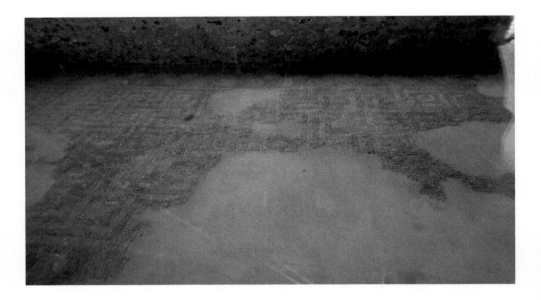

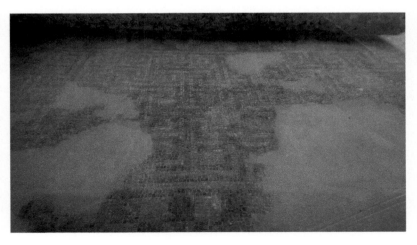

Above and left: A Roman mosaic within the town house.

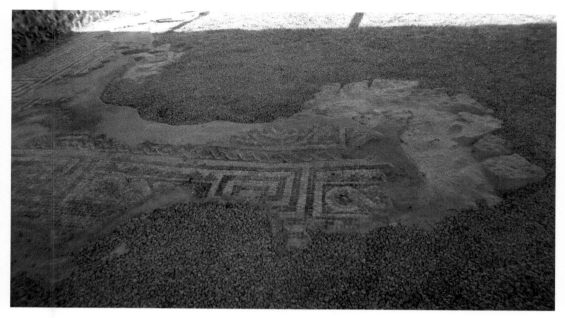

A Roman mosaic within the town house.

The well that can be seen in the grounds of the town house today is the original well, but the brick and flint structure that can be seen above ground was added in 1950.

In Roman times the water from the well was used for drinking, washing and cooking.

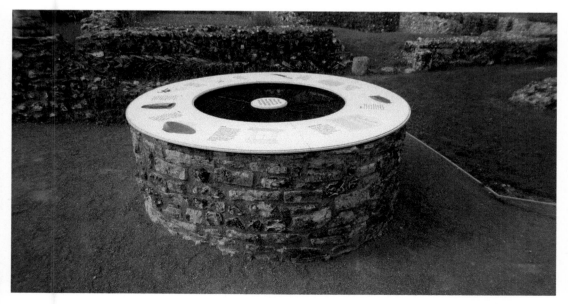

The Roman well in the Roman Town House – the structure above ground was added in 1950.

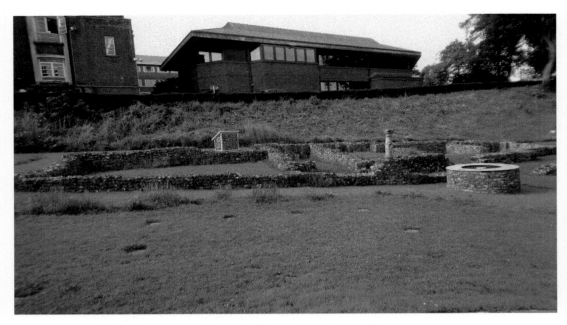

The low walls are the remnants of an outbuilding called the South Range.

Durnovaria in the Immediate Aftermath of the Roman Withdrawal

When the Roman Legionnaires moved onwards in the fourth century, the residents remaining behind were thought to be a mixture of retired Roman soldiers and various traders and craftsmen.

3. Cerne Abbas

The Cerne Abbas Giant

The village of Cerne Abbas, situated 6 miles to the north of Dorchester, possesses one of Britain's largest and most well-known chalk figures, the Cerne Abbas Giant. He is an

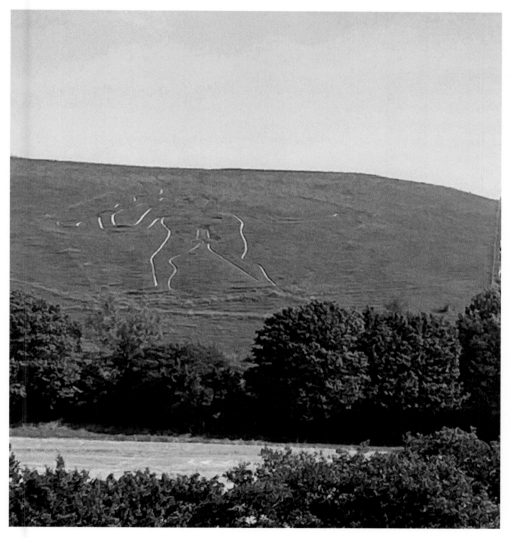

The Cerne Abbas Giant.

imposing 180-foot figure (I'll let the picture speak a thousand words) who brandishes a large club. He is cut into the side of a hill known as Giant Hill or Trendle Hill, on top of which is an Iron Age earthwork known as the Trendle or Frying Pan.

There are several theories as to the origin and age of the giant and the issue is clouded by the fact that no reference to the giant can be found in the village's historic documents until it was mentioned in the churchwarden's account for St Mary's Church in 1694. However, this could be explained by the fact that many official records of the village were lost with the Dissolution of the Abbey in 1539.

Like most other interesting landmarks in the Dorchester vicinity, the figure features in Hardy's novels and makes an appearance in both *The Woodlanders* and *Tess of the D'Urbervilles*.

Theories as to the Age of the Giant

Ancient Man

For years it was assumed that the Cerne Abbas Giant was created by ancient man and adding credence to this theory was a survey undertaken by the National Trust which studied the small round hill below the giant's left hand. The survey established that the giant was originally carrying a severed human head, leading experts to postulate that the giant was depicted as having just defeated an enemy in battle.

However, other advocates of the Ancient Man theory say, for obvious reasons, that it is an Iron Age Celtic fertility symbol.

The Cerne Abbas Giant has also been linked to a similar bronze figure found 12 miles away at Hod Hill. The figure has been identified as being from the first century and he is considered to be a Celtic god of healing and fertility. He has wings and is clutching a club in one hand and a dead hare in the other.

Romans

Another theory is that he is a portrait of the demigod Hercules, drawn by the Romans. The thinking behind this belief is that the club was often a symbol of the Roman god Hercules and tests have also suggested that the giant may have originally been depicted wearing a lion's skin, which is also a feature associated with Hercules.

The Roman association is further supported by terracotta statues that were excavated at the site of a former Roman barracks in Arles in France, which depict a similar-looking giant.

Saxons

Some historians believe that the figure is of Saxon origin and that he may have been created in homage of the Saxon god Helith.

Monks

Another possibility is that the figure was constructed by the Benedictine monks from the Abbey, as a similar mysterious figure, the Long Man of Wilmington, found on a hill near

Eastbourne in Sussex is thought to have been cut by Benedictine monks at the nearby Wilmington Priory.

Seventeenth Century
Denzil Holles owned the land which included Giant Hill from 1642 to 1666 and was a not a great fan of Oliver Cromwell, despite having fought for the Parliamentarians himself during the Civil War. Accordingly, it is considered that it is possible that the giant is a parody of Cromwell, as his supporters referred to him as Hercules.

Snails
In May 2021, scientific researchers claim to have settled the argument for good with an unlikely combination of laser beams and snails.

The environmental archaeologist Mile Allen studied soil samples from the giant and from analysing minute differences in whorl patterns and hair pits with laser beams, was able to identify their species. He discovered that two of the snail species were only around in England during medieval times, leading him to conclude that the figure had been grassed over for years before it was discovered and that the giant was constructed between AD 700 and AD 1100 in the late Saxon or early medieval period.

Local Folklore
Local folklore insists that if a woman sleeps on the phallus, she will bear many children. It is also believed that a cure for infertility is for a couple to make love on the phallus.

Another legend associated with the giant was that he was a real-life ogre who marauded around Cerne Abbas, being generally anti-social and stealing sheep, until finally the local residents, assisted by the fairies, put a stop to it by catching him and pinning him to the hillside.

The Trendle
Just above the giant's club a square outline can be seen, which is the remnants of an Iron Age site known as the Trendle. It is believed to have been a former temple.

For many years it was a local custom for childless couples to perform a fertility dance around a maypole positioned on the Trendle on May Day. That particular element of the tradition is no longer performed; however, on 1 May Wessex Morris Men still dance on the Trendle, before moving on to the village square.

Cerne Abbey
A Benedictine abbey was established on the banks of the River Cerne in AD 987, but all that remains of the abbey now is the Abbot's Porch, the Abbey South Gate House, the Abbey Guesthouse and two barns situated slightly distant to the abbey in opposite directions, one of which is a tithe barn.

Cerne Abbey was an important monastery in Dorset and rather like the village's other main attraction the chalk giant, has attracted numerous theories as to its origin.

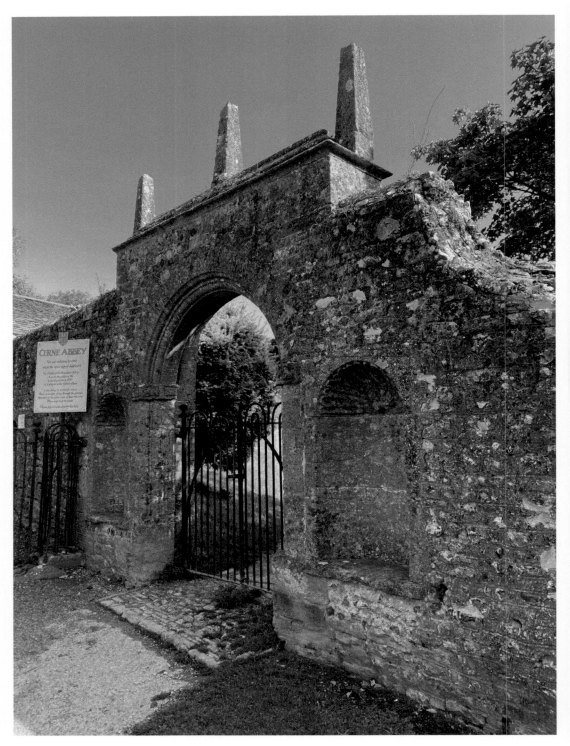

The entrance to the grounds of Cerne Abbey.

Different Theories Relating to the Founding of the Abbey

One version suggests that St Augustine and his followers visited Cerne Abbas in the sixth century and preached on the spot now marked by St Augustine's Well.

It seems that initially the local inhabitants were unwilling to accept Christianity and forced St Augustine to leave. However, they then regretted that decision and overcome with remorse, invited them back. St Augustine believed this was a divine intervention and subsequently named the settlement as Cernel, which was a Hebrew and Latin word meaning God's decision. He is then said to have struck his staff on the ground to create a well and used the water to baptise the new Christians.

Another version states that in AD 870, St Edwold came to live in Cerne Abbas as a hermit, having refused to accept the crown of East Anglia after his brother King Edmund's death at the hands of the Danes. He is thought by advocates of this theory to have set up camp on a hill around 4 miles from Cerne Abbas.

Others say that in fact St Edwold lived as a hermit at St Augustine's Well and that in AD 987, King Edgar founded an abbey near the site of St Edwold's hermitage and gave Aethelmaer, Duke of Cornwall, the task of overseeing the construction of the new monastery.

Another version says that Aethelmaer was gifted the abbey by a relative, and yet another version says that the abbey was founded by Aethelmaer himself.

Cerne Abbey Continued

King Cnut, who was on the English throne from 1016 to 1035, became a great benefactor of the abbey, once he had seen the light after his previous plundering of both the town and the abbey.

However, a later English king, Henry VIII, was less sympathetic to abbeys and destroyed them all in the Dissolution of the Monasteries between 1536 and 1541, after having just declared himself the head of the English Church instead of the pope. He did this to enable him to divorce his first wife, Catherine of Aragon, and marry Catherine's lady in waiting, Anne Boleyn. This period was known as the Reformation, as the official religion of England changed from Catholic to Protestant.

Consequently, Cerne Abbey's days were numbered and in spite of attempts by the last incumbent Abbot, Thomas Corton, to save the abbey, it was seized by John Tregonwell on behalf of the Crown, on 15 March 1539.

Much of the material salvaged from the rubble of the abbey was used in the construction of the village and recognizable remains can be found all over Cerne Abbas, so much so that in 2021, the Cerne Historical Society launched an appeal for people to come forward if they were aware of any fragments of the abbey that they had in their gardens or house, just to try and correlate and understand a bit more about the history of the abbey.

DID YOU KNOW?

Before its dissolution the abbey was involved in an unedifying scandal, as the last Abbot, Thomas Corton, was at the centre of numerous complaints that he was keeping a harem of concubines on the premises and was allowing the abbey to go to rack and ruin.

Abbey South Gatehouse

The Abbey South Gatehouse was used as a farm building and this probably enabled it to survive Henry VIII's Dissolution.

A Grade I listed building has evolved around the original South Gate and incorporates the core of the original Gatehouse. The majority of the building was destroyed in a fire in the eighteenth century and most of what is left dates from after that period. However, a lot of original materials from the abbey were used in the reconstruction.

It is now a private residence and is one of the few remaining Abbey Gate Houses in the West Country.

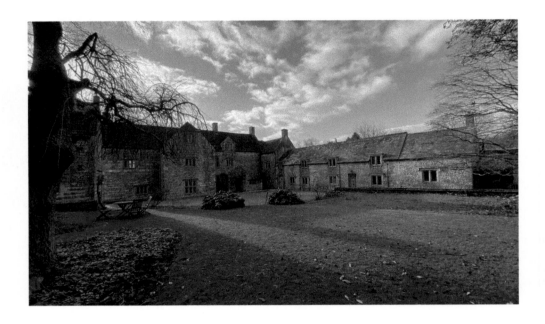

Above: Abbey South Gate House.

Left: Front view of Abbey South Gate House.

Abbey Guesthouse

The Abbey Guesthouse is also a Grade I listed building and was built by Abbot Vanne in the fifteenth century to accommodate travelers.

Right and below: Abbey Guesthouse.

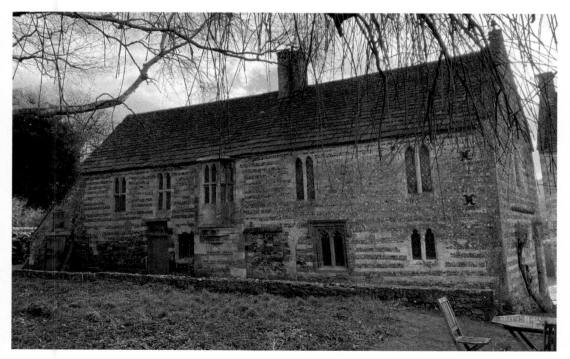

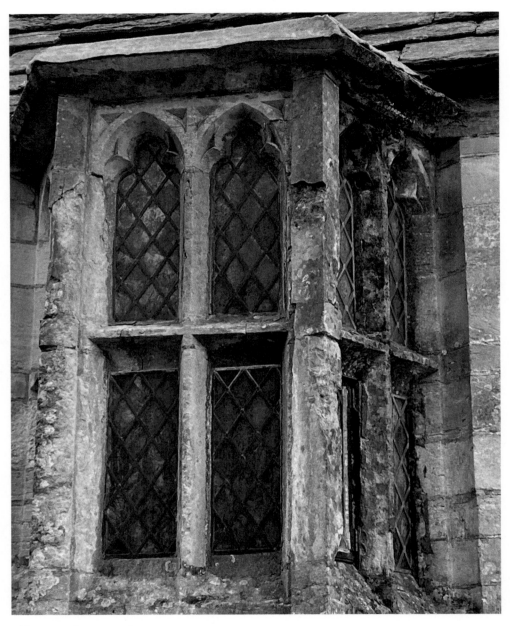

Abbey Guesthouse window.

Abbot's Porch

The Abbott's Porch again is a Grade I listed building. It was built in the early sixteenth century as the entrance for the whole complex, and also included living quarters above the entrance. Its main feature is a superb oriel window with panels containing heraldic coats of arms.

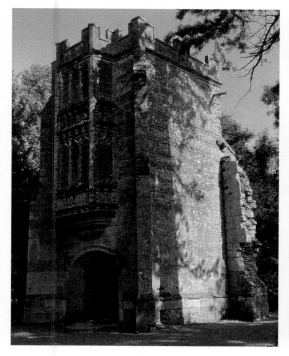

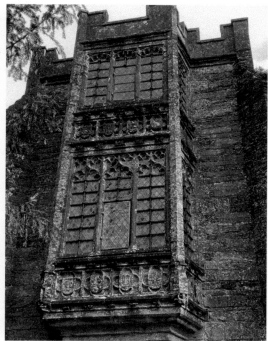

Above left: Abbot's Porch.

Above right: The stained-glass window of the Abbot's Porch replete with heraldic crests.

Tithe Barn

In its time the abbey was the biggest landowner in the area and tenant smallholders from the local villages and towns were required to pay rent in the form of a tithe,

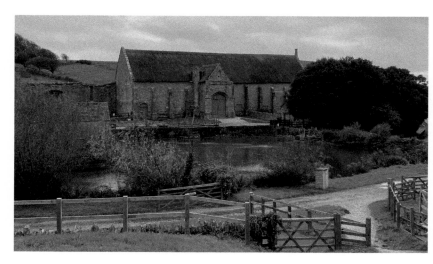

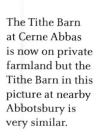

The Tithe Barn at Cerne Abbas is now on private farmland but the Tithe Barn in this picture at nearby Abbotsbury is very similar.

where one tenth of the annual produce was taken as a tax to support the abbey and monastery.

The thirteenth-century Grade I listed Tithe Barn was used to store the produce. The barn still stands but it now forms part of the garden of a private house.

Silley Court Barn and Kettle Bridge

Kettle Bridge was constructed to enable carts to carry grain across the river to the Silley Court Barn (now Beauvoir Court). The barn was associated with the abbey and was where the grain was stored, before it was taken to the abbey mill to be made into flour to make bread.

Silley Court Barn is a Grade II listed building and now forms part of a private house.

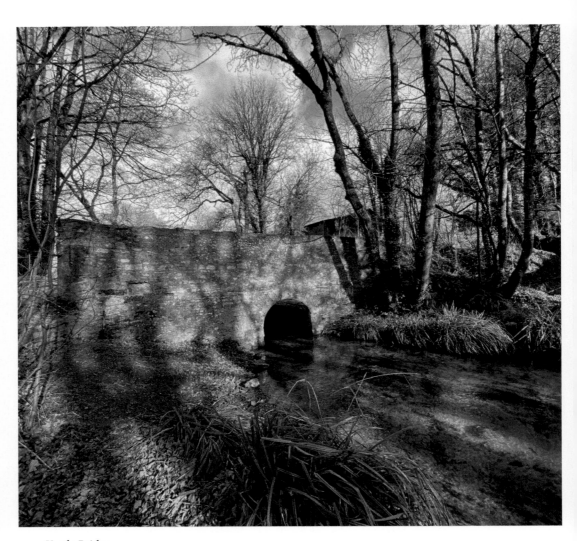

Kettle Bridge.

St Augustine's Well

As we have seen, St Augustine is said to have visited Cerne Abbas in the sixth century and preached on the spot now marked by St Augustine's Well. He is also considered by many to have founded the abbey.

As with St Augustine's association with the abbey, there is also much legend connected to the founding of St Augustine's Well.

One legend is that he offered two shepherds a choice of beer or water to drink and when they chose water, he struck his staff on the ground and water gushed forth from a spring. The alternative version is that he rewarded them with a brewery for their piousness.

Another legend concerns St Edwold, who when wandering through the Dorset countryside feeling tired, hungry and thirsty, had a vision of a silver well. He sought the help of some shepherds who gave him some bread and water and showed him the whereabouts of a well that he could drink from.

On reaching the well, St Edwold recognised it as the silver well of his vision and saw that as a sign to set up a hermitage, where he lived until his death in AD 871.

Legends also abound as to the curative properties of the water and although not officially tested as safe to drink, it is still reputed to be drinkable in early spring when the water is gushing freely, but not in late summer and autumn when the water is more stagnant. Indeed, up until the Second World War the water from the spring was used by the villagers as drinking water.

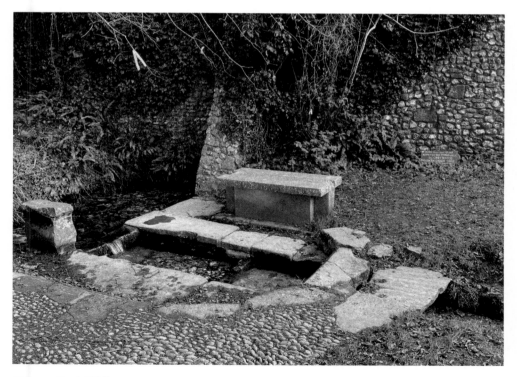

St Augustine's Well.

The Preaching Cross

The remains of a fifteenth-century preaching cross can be found at Cerne Abbas burial ground. It is made from hamstone quarried from Ham Hill near Montacute.

Book of Cerne

The Book of Cerne is a beautifully illustrated Anglo-Saxon book of prayers and devotions. The book was believed to have been made in Mercia or Wessex and was owned by Aethelwold, the Bishop of Lichfield from AD 818 to AD 830 when he died.

In reality the Cerne Abbey connection with the book is merely that the prayer book was bound by Cerne Abbey library manuscripts and resided in the library of Cerne Abbey. The book was removed from the abbey library for safe keeping in order to survive the Dissolution of the Monasteries and was sold in 1715, by the Bishop of Norwich and Ely, to George I, who in turn presented it to Cambridge University where it is now stored.

Domesday Survey

The Domesday Book of 1086 records that Cerne Abbas contained a population of twenty-six villagers and thirty-two smallholders and that the abbey owned significant amounts of property around Dorset.

St Mary the Virgin Church

The villagers are thought to have worshiped at the abbey until St Mary the Virgin Church was built by the monks in the fourteenth century. The tower and the attatched gargoyles were not completed until the late fifteenth century.

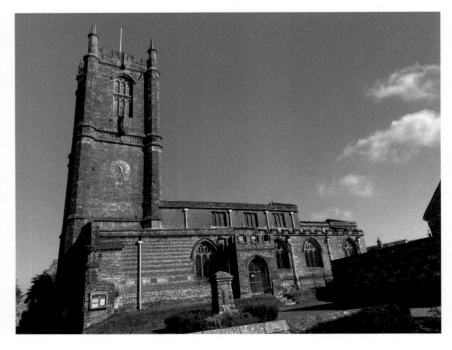

St Mary the Virgin Church.

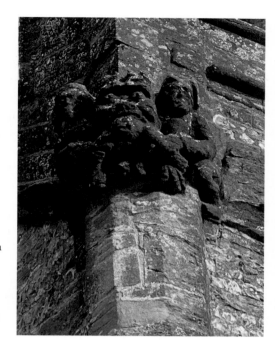

Right: Gargoyles on the tower of St Mary the Virgin Church.

Below: Stocks were a staple medieval punishment for crimes against the community such as selling poor-quality produce, and some wooden stocks can still be seen by the side of the church.

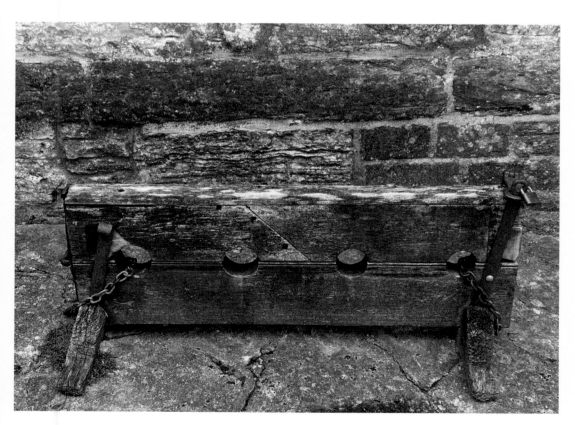

Cerne Abbas Village

The village of Cerne Abbas grew in the shadow of the abbey and the initial development in the fifteenth century occurred in Abbey Street.

The Abbey South Gate House is situated at the north end of the street and what is known as the Market Square is at the other end of the street of medieval timber-framed houses, which were once on both sides and accommodated the abbey's more senior workers.

The building at The Market Square end of the street is called the Pitchmarket as this is where farmers pitched their corn sacks to display their wares on market day. It is now a Grade I listed building and a private residence.

Abbey Street.

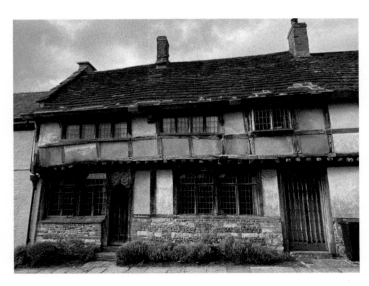

Pitchmarket House.

In 1539, the dissolution of the abbey saw the village lose its livelihood and then subsequent private landlords of the manor of Cerne Abbas strip the abbey's materials for profit.

The seventeenth century saw a rise in the village fortunes. However, Cerne Abbas, like most places in the country, did not escape the ravages of the English Civil War and suffered the common fate of most towns in the West Country of being occupied at different times by the armies of both protagonists.

In 1645, Cromwell himself paid a visit and was probably well received in some quarters, as like a lot of the West Country Cerne Abbas was experiencing a rise in Nonconformist religious beliefs at the time.

At the beginning of the eighteenth century, the village came under the control of the Stratfield Saye estate and once again began to prosper as a small market town of 1,500 people, involved in various industries including silk spinning, boot making, milling, tanning and glove making. However, the most important industry was brewing, for which Cerne Abbas had gained a great reputation. The village also possessed numerous coaching inns during this period, where the beer could be utilised.

In the middle of the nineteenth century, many rural Dorset villages were suffering and farm labourers in Cerne Abbas, like other villages in the vicinity including the nearby village of Tolpuddle, were experiencing near starvation conditions. As a result, the Cerne Abbas Union Workhouse was established in 1832 and continued until the twentieth century. The situation was exacerbated when the railways bypassed the village, meaning the coaching inns were no longer required.

The village was at its lowest ebb at the beginning of the twentieth century, but then in 1919, the village was sold by the Pitt Rivers estate and as a result the village began to become more prosperous.

Beer

In the seventeenth and eighteenth centuries Cerne Abbas became famous for its beer. So much so that in 1747 the village possessed seventeen public houses, which may seem excessive, but Cerne Abbas was a major interchange for several coaching routes at the time and thus required numerous coaching inns.

The locality of Cerne Abbas is fortunate to possess the natural attributes of a green sand and chalk geology, which is highly conducive to producing water which is ideal for brewing. As a result, Cerne Abbas became the original centre of British brewing and beer was exported as far afield as the Americas.

Another contributing factor was an expert brewer among the Benedictine monks known as Ethelmaer the Stout, who passed on his skills to the other brothers.

In the nineteenth century the industry went into decline when the number of coaching inns declined as the village was overlooked in the coming of the railways.

In 2016 after 130 years, brewing returned to Cerne Abbas in the form of Cerne Abbas Brewery situated just outside of the village.

Pubs Today

Today, only three pubs remain in the village, plus the Cerne Abbas Brewery.

The New Inn

The building that accommodates the New Inn was originally a thirteenth-century wool merchant's house consisting of a central fireplace. It became a coaching inn in 1701 and continued in that guise until 1855.

The building was also used for petty court sessions during that period, but that stopped when a police station was built with an attached courthouse in 1860. The hostelry now boasts a courtyard and ten hotel rooms.

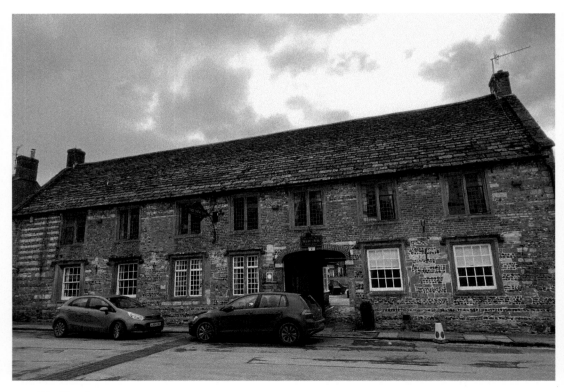

The New Inn.

The Giant Inn/Red Lion

The Giant Inn was previously the Red Lion, and that name is still retained in the title in order to prevent confusion. It is one of the original coaching inns and is the last remaining free house in Cerne Abbas.

It was rebuilt in 1898 after a major fire, but the fifteenth-century fireplace survived. The pub also retains a traditional skittles alley and must be one of the only pubs in the country with a dual name.

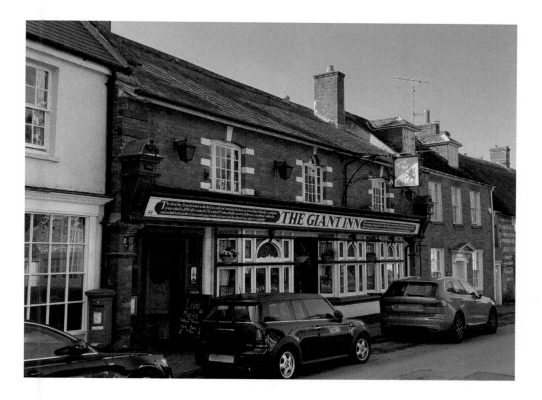

Above: The Giant Inn/Red Lion pub.

Right: The Giant Inn/Red Lion pub sign.

The Royal Oak

The Royal Oak dates back to 1540 and originally consisted of three cottages made from timber and stone salvaged from the abbey after the Dissolution of the Monasteries. This is still apparent in the pub today, particularly in the case of the attractive wooden beams of the ceiling.

The building was originally a coaching inn and blacksmiths.

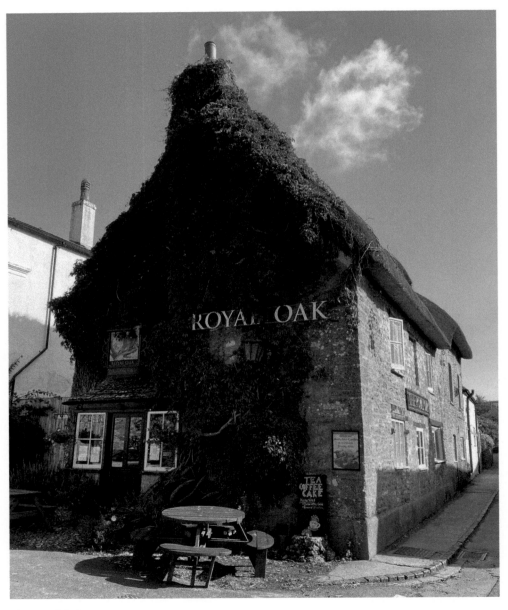

The Royal Oak.

The Smiths Arms at Godmanston

There used to be a very interesting pub between Cerne Abbas and Dorchester at Godmanston called the Smith's Arms, which is unfortunately no more. It was a quaint thatched Inn, reputed to be the smallest in England.

It was originally a blacksmith's, but was granted a licence by Charles II in 1665. Apparently while hunting in the area the King called in and asked for a drink, but was told that there was no licence. The King granted one on the spot and was thus able to immediately alleviate his thirst.

The former Smiths Arms, Godmanston.

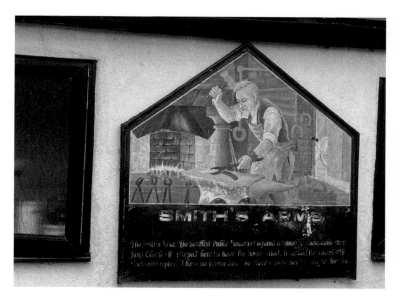

A mural on the side of the Smiths Arms.

4. The Monmouth Rebellion's Impact on Dorchester in the Form of the Bloody Assizes

Dorset has been the stage for various historical events over the years, not least of which was the Monmouth Rebellion of 1685, which started at Lyme Regis and subsequently saw the county pay a horrifyingly heavy price, as the feared and loathed Judge Jeffreys wrought shocking and violent retribution throughout the West Country and particularly in Dorchester during the Bloody Assizes.

The background to the rebellion was the years of strife between Protestants and Catholics, which was accentuated when King James I became King of England in 1603 and persecuted both the Catholics and the Protestant Puritans. The Catholics responded with many plots against him, one of which was the Gunpowder Plot to blow up Parliament on 5 November 1605.

Meanwhile Protestant Puritans were leaving the country as Pilgrims. The first group to do so was the Pilgrim Fathers, who left England's shores in 1620, bound for America from Plymouth. They were followed by many other Protestant Nonconformist Puritan settlers from the South West and elsewhere.

John White, who is often referred to as the Patriarch of Dorchester, who was the Rector of the Holy Trinity and St Peter's Church from 1606 to 1648, organised and raised funds for Pilgrim Puritan settlers to sail to America in three ships, the *Fellowship, Amylic and Pilcrine*.

DID YOU KNOW?
John White organised the relief campaign after the great fire of Dorchester in 1613. His body lies in the porch of St Peter's Church.

The Dorchester pilgrims founded the colony of Massachusetts and settled in an area they named Dorchester after their native town. The American version was originally a city in its own right but is now an area of Boston.

Charles I became King in 1649. He believed in the 'Divine Right of the Monarchy' and didn't take kindly to advice from a Parliament, now dominated by Protestant Puritans, who were opposed to the Divine Right of the Monarchy and the supremacy of the monarch in religion. Charles I further antagonised his Protestant Puritan detractors by marrying a French Catholic princess, Henrietta Maria.

King and Parliament were at loggerheads, and Charles decided to have five of the leading Puritans arrested. This precipitated the English Civil War (1642–51), the Protestant Puritan, Parliamentarian Roundheads against the predominantly Catholic, Royalist Cavaliers.

Dorchester was a bastion of Puritanism and consequently was on the side of the Parliamentarians. However, despite the intensification of fortifications, particularly at Maumbury Rings, the Royalists captured and plundered the town in 1643. The Royalist Cavalier soldiers were then moved on to fight elsewhere, but upon their later return they were defeated by the Dorchester Puritan defenders.

The conflict resulted in Cromwell's Protestant force becoming victorious, but religious friction still existed and came to the fore again prior to the Monmouth Rebellion of 1685.

The Main Combatants of the Monmouth Rebellion

King James II

King James II was born in 1633, to parents Charles I and Henrietta Maria. He came to the throne in 1685, having succeeded his brother, Charles II, and was crowned at Westminster Abbey as King James II of England, Wales and Ireland, and James VII of Scotland.

He believed in the 'Divine Right of Kings', and had the intention of making the nation Catholic again.

He married Anne Hyde in 1660, and they had four sons and four daughters. However, only two of the children, Mary and Anne, survived. When Anne Hyde died, James married Mary of Modena of Italy in 1673, with whom he had a further two children. She was a devout Catholic like himself.

The Duke of Monmouth

The Duke of Monmouth was the illegitimate son of King Charles II. He was born in the Netherlands on 9 April 1649, where he spent his early years under the care of Lord Crofts.

The Duke of Monmouth always claimed that his mother, Lucy Walter, was the legal wife of King Charles II, and therefore his birth was not illegitimate. He claimed they were married in a private ceremony in the Netherlands and that his mother had a black box containing the wedding certificate. King Charles II, on the other hand, denied this, and said that he only ever had one wife, Catherine of Braganza.

Lucy Walter, Monmouth's mother was an attractive Welsh lady who met Charles II at The Hague when he was in exile. Although he certainly treated his son very well and was fond of him, King Charles II did not acknowledge his son publicly, until Monmouth married Anne Scott, Countess of Buccleuch, in 1663. Upon his marriage, Monmouth took the surname of Scott as his own.

Charles awarded various titles to his son – the Duke of Monmouth, the Duke of Orkney and the Knight of the Garter – and then in 1670, he made Monmouth Commander in Chief of the Army, before promoting him to Captain General in 1678.

Monmouth went on to prove himself as a charismatic, courageous and capable soldier in the defeat of the Scots at Bothwell Bridge in 1679. He also led a successful campaign in the Netherlands during the Third Anglo Dutch War (1672–74), where he defeated the Dutch at the Siege of Maastricht (1673).

Charles II was urged by influential Protestants to legitimise Monmouth, but he refused, and historians speculate that this was because Monmouth's mother was a commoner.

The Protestant Duke of Monmouth became a figurehead for those working to prevent the Catholic Duke of York (later to become James II) succeeding to the throne.

On the death of King Charles II, and the accession of the Duke of York to become James II on 23 April 1685, Monmouth decided to fight for what he believed was his rightful place on the throne.

Monmouth Lands at Lyme Regis

A task force under the command of the Earl of Argyll had already set sail from the Netherlands on 2 May 1685 and landed in Scotland.

The Scottish arm of the rebellion was already staring defeat in the face by the time the task force detailed to land in the south-west of England, including Monmouth himself on the thirty-two-gun frigate *Helderenburg*, landed at dusk on 11 June 1685, on a shingle beach to the west of Lyme Regis Cobb.

Lyme Regis was considered a suitable spot to land as it would allow the rebels a considerable head start before King James II's Royal Army could be mobilised from London. It was also considered near enough to the Netherlands to reduce the risk of the Royal Navy intercepting the convoy, and was not too far from the initial target of Bristol, which was then England's second city.

Upon landing, Monmouth raised his standard, which consisted of a green banner with the words 'Fear nothing but God' emblazoned on it in gold. He announced that he had come to defend the Protestant religion and to deliver the country from Catholicism and the tyranny of James II. He also promised freedom of worship to Nonconformists and Anglican Protestants alike. The entire party then sank to their knees in prayer.

As this was happening, two Lyme Regis customs officials informed the Mayor, Gregory Alford, who galloped to London to inform the MP for Lyme Regis, Sir Winston Churchill (an ancestor of the Second World War leader), who in turn informed King James II.

On the King's command, John Churchill, the future Duke of Marlborough (the Lyme MP Winston's son), who was in command of the Regular Foot of the King's Army, began to mobilise his army.

The Rebellion and the Battle of Sedgemoor

The rebels involved a significant proportion of the populations of West Dorset, East Devon and particularly Somerset. The rebellion was crushed at the Battle of Sedgemoor on 6 July 1685, the last pitched battle to occur on English soil.

Monmouth's Flight

Monmouth showed great courage during the battle, but when defeat was inevitable he took flight as the last of the battle raged on. He travelled on horseback into the Polden Hills, before changing direction at Shepton Mallet. He then headed south into Dorset in an attempt to get to Poole, where he planned to board a ship to the Continent.

Notices were soon posted all over the countryside offering a sizeable reward for his capture, as the area quickly filled with troops.

Initially, Monmouth was with three companions, but the group had to leave their exhausted horses behind at Woodyates on Cranborne Chase, Dorset, where they disguised themselves as shepherds, split into two groups and continued on foot. Two of his companions, Lord Grey and Richard Hollyday, were caught near Holt, Dorset, in the early hours of 7 July. Meanwhile the rebel leader and his German companion, named Buyse, fled across Horton Heath. On 8 July, an old lady, Amy Farrant, spotted them climbing through a hedge, and alerted the soldiers to their hiding place.

Buyse was caught, and not long after, another exhausted wretch was found by militiaman Henry Parkin, hiding in the bracken underneath an ash tree in a pea field. He was disheveled and hungry and dressed in shepherd's clothing. On searching him, Parkin soon realised this was no shepherd, as he found a badge of the Knight of the Garter and several gold guineas.

The spot in which the Duke was captured is still known as Monmouth's Ash, although the actual tree has long since gone. It was near Slough Lane in Horton, Dorset. There is a farm nearby called Monmouth Ash Farm, as well as a pub in nearby Verwood called the Monmouth Ash.

Monmouth's Beheading

Monmouth's pleading for leniency from his uncle fell on deaf ears. No royal pardon was forthcoming, and James duly signed his nephew's death warrant. Monmouth was then escorted from Ringwood to the Tower of London to be executed.

By now resigned to his fate, Monmouth met his end on 15 July, with the same bravery as his grandfather, Charles I, had shown at the same venue of Tower Hill.

As a nobleman, the Duke was entitled to be executed by beheading, rather than the more barbaric hanged, drawn and quartered method. However, he suffered terribly as a blunt axe was wielded by an unskilled executioner by the name of Jack Ketch.

This was only the beginning of the reprisals. The Western Counties were to suffer severe consequences for the failed rebellion.

Judge Jeffreys and the Bloody Assizes

After Sedgemoor, James II set up a special commission to conduct the Assizes in the south-west of England. The commission was overseen by Judge Jeffreys, and also included Chief Baron Sir William Montague, Sir Robert Wright of the Exchequer, Sir Francis Wythens for the King's Bench and Sir Creswell Levinz of the Common Pleas. Such a large Commission was needed because of the sheer volume of prisoners awaiting trial.

Town and village officials were required to provide a list of all those who had been absent from their homes during the rebellion, and in most cases this was the only evidence on which the prosecutions were based.

At the age of forty, Jeffreys was the youngest and most brutal Lord Chief Justice of England, and his malicious conduct had made him a firm favourite with King James II. He had gained a deserved reputation for cruelty, which, allied to his barbaric behaviour at the Bloody Assizes, was soon to give him the nickname of the 'Hanging Judge'. He was a

Protestant himself, and it was as though he felt he had to overcompensate in showing that he had no sympathy with the rebellion, as he toadied up to the Catholic King James II.

Absolute Carnage at the Dorchester Bloody Assizes

It seems likely that the King and Jeffreys were influenced by the fact that Dorchester had been a thorn in the Royalist's side during the Civil War and as a result, the Assizes really became the Bloody Assizes at Dorchester and beyond, as they became even more savage and barbaric. There was no leniency, as adults of either sex, or children as young as ten or twelve were beheaded or transported.

Before the trial began he had ordered that the gallows be erected in the most prominent position in the town. He was determined to create a shocking example to deter people from treasonable thoughts of defying the King.

He also ordered the Oak Room of the Dorchester Assize Court to be adorned with red, to set the tone and provide a grim reminder of what lay in store for the prisoners. The painful kidney stone he was suffering from at the time didn't help his mood.

DID YOU KNOW?
The old Dorchester Assize Court became the Antelope Hotel, but became a passageway containing retail outlets called Antelope Walk in the 1980s.

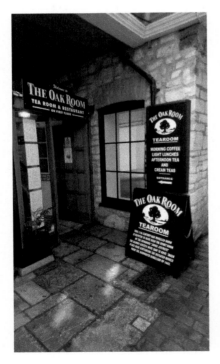

The Oak Room dates back to 1589 and was a cafe of the same name within Antelope Walk. It still maintains the original oak panelling. It has now changed hands and become the Court House Bistro.

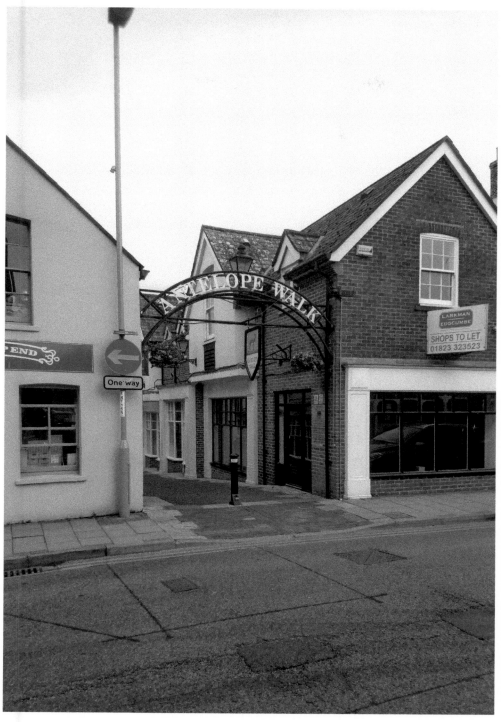

The old Dorchester Assize Court became the Antelope Hotel, but is now a passageway, called Antelope Walk, containing retail outlets.

The Oak Room was, until recently, a café of the same name, within Antelope Walk, which still maintained the original oak panelling. However that establishment seems to have unfortunately been a victim of lockdown and the venue has reopened under new ownership as the Court House Bistro (2022).

The table and chair that Judge Jeffreys used are now in the chamber of the Corn Exchange.

Judge Jeffreys' Lodgings

The rooms where Judge Jeffreys lodged at 6 High West Street, Dorchester, during the Bloody Assizes are now the Judge Jeffreys Restaurant and Coffee House and it is one of the oldest buildings in Dorchester, dating to at least 1398. The interior boasts Tudor

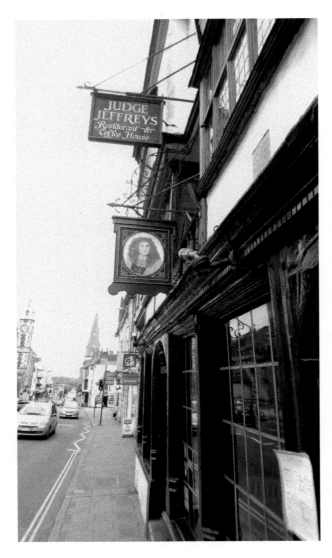

The rooms where Judge Jeffreys lodged at 6 High West Street, Dorchester, are now the Judge Jeffreys Restaurant and Coffee House.

fireplaces and seventeenth-century wood panelling. The ground-floor windows are Victorian but the windows upstairs are much older.

Jeffreys is said to have used a secret underground passageway to travel between his lodgings and the courtroom. Apparently the tunnel was sufficiently large for three people to walk side by side.

No. 6 High West Street has seen a lot of history; it was also used as a Parliamentarian headquarters during the Civil War and ironically the Duke of Monmouth also stayed here whilst plotting the rebellion.

It is said that the establishment is haunted. Slamming doors and footsteps have been heard at night and some claim to have seen a Civil War Cavalier at large.

The timber-framed premises have survived several fires in the town including the major fire of 1613, but unfortunately these premises also seem to have been a victim of lockdown and are currently lying vacant (2022).

Jeffreys stated, as he also did at other trials, 'that if any pleaded not guilty, and were subsequently found to be guilty, they would not have long to live; and that, if any expected favour they should plead guilty'. Many prisoners had seen enough of him not to trust him to honour his word, or show any leniency; and indeed, those that did plead guilty expecting mercy, received none.

Those involved in the rebellion were sentenced to high treason, for which the penalty was death. In the case of a commoner, the method of execution was to be hanged, drawn and quartered. This involved being fastened to a hurdle and dragged

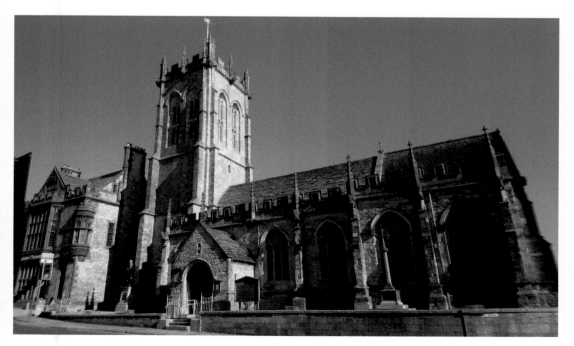

St Peter's Church, where many severed heads from the Bloody Assizes were placed on spikes to cower the local population.

by a horse to the place of execution, where he was then hanged almost to the point of death. The victim then had his genitals cut off, before being slit from the breastbone to the groin, whereupon his entrails were pulled out and then burnt in front of him. Next he was beheaded and then quartered – chopped into four pieces. The pieces were then tarred to preserve them and put on public display in gibbets in prominent places.

In Dorchester, Judge Jeffreys sentenced 313 rebels to receive the death penalty, although in the end only seventy-four actually received that sentence. This was mainly because the executioners, Mr Ketch and his assistant, Pascha Rose, were struggling, as the hanging, drawing and quartering was a time-consuming process and they complained that they could only cope with thirteen of these a day.

As a result, Jeffreys agreed that thirteen should be dealt with in Dorchester and the rest should be farmed out in batches to Bridport, Weymouth, Poole and Wareham.

He also reluctantly agreed that it would be more expedient to commute many of the sentences to lesser punishments. So in the event, 175 were transported to the West Indies as slaves, which was tantamount to a death sentence anyway. Fifty-five were pardoned and nine were publicly whipped.

Another issue was that the number of prisoners awaiting trial resulted in Dorchester gaol being full to capacity, so All Saints Church was used to take up the slack. As a result, the building was severely damaged and also had to be fumigated afterwards due to an outbreak of smallpox and fever among the prisoners.

Some shocking travesties of justice and dastardly foul play occurred, one incidence of which involved William Bragg, who was a lawyer by profession. He wasn't a Monmouth rebel but his horse was stolen by Monmouth's men and he had been seen entering their camp in order to reclaim it.

Whilst trying to explain his case in court to Jeffreys, he was cut short by the enraged judge, who simply said, 'He is a lawyer, hang him.'

Later that evening, after presiding over many further appalling miscarriages of justice, it is said that Jeffreys persuaded a young girl to share his bed on the promise that doing so would ensure her brother's freedom. The poor girl awoke the next morning to the sight of her brother swinging from the gallows.

Legend has it that the very next morning, a Sunday, Judge Jeffreys attended service at St Peter's Church opposite his lodgings and when the vicar extolled the virtues of clemency, he could barely contain his mirth.

King James II realised that a considerable income for the treasury could be raised by selling the convicts to middlemen, who then shipped them to the West Indies sugar plantations for profit. Some prisoners were kept by King James so that he could profit directly from their sale; others were given as gifts to his favourites so they could profit. Many didn't survive the six-week voyage, as they were kept in cramped conditions under the deck of cargo ships not designed for this purpose. There was no room to lie down, and contagious diseases were rife.

In theory once the slaves had served a ten-year sentence they were free to return to England, but very few were actually able to do so. However, when William and

Mary came to the throne in 1689 they issued a general pardon. Those that did manage to return reported the horror of slavery. Others were sentenced to receive public floggings. Lord Grey, the officer in charge of the Rebel Cavalry, was sentenced to be whipped through Dorchester on market day, and then to receive the same punishment on market day in Shaftesbury. Others were whipped through all of the towns of Dorset.

In many instances, those of higher social status received less severe punishment. In the case of Lord Grey, his wealth was in life estate, which meant if he died, his land went to his heir, whereas if he were pardoned he would be able to pay a large ransom. Jeffreys extorted £40,000 from him, in return for the more lenient sentence of a public whipping as opposed to the death penalty.

St Peter's Church, Dorchester

St Peter's Church, which is opposite Judge Jeffreys Restaurant and Coffee House, was built in the fifteenth century.

During the Bloody Assizes, many severed heads were placed on spikes outside the church to cower the local population. The church also features in several of Thomas Hardy's novels.

Dorset Red Posts

The mysterious red posts in Dorset are believed to be associated with the Bloody Assizes – the red signifying blood. They are considered to be sites of gallows, and they are also thought to have doubled up as gibbets, where Judge Jeffreys ordered body parts from those that were hanged, drawn and quartered to be put on public display.

Many believe that these gallows had another use in speeding up the columns of prisoners being forced-marched to ports for transportation. This was achieved by simply hanging those who lagged behind. Some believe that the red posts also acted as route markers for the illiterate guards to escort convicts to the transport ships in Poole, Weymouth and elsewhere.

The red post on the A31 close to Bloxworth and Anderson in Dorset around 14 miles from Dorchester is near what was Botany Bay Farm. It possessed a barn complete with shackles on the walls, and was used as an overnight holding bay for prisoners en route to Poole for transportation. The building has long since been destroyed and an agricultural machinery depot is now at the same site.

The World's End and Botany Bay pubs situated close to the Bloxworth red post on the A31 east of Dorchester also reflect the grim legacy of transportation in these parts, although the names of the pubs are such that they seem to mainly refer to times after the Monmouth Rebellion and after the American War of Independence (1776–83), when America gained independence from Britain, meaning that prisoners could no longer be transported to British American colonies and were instead transported to Australia rather than the West Indies. However the Botany Bay pub also refers to the Botany Bay Farm holding area for prisoners, which was very much in use immediately after the Bloody Assizes.

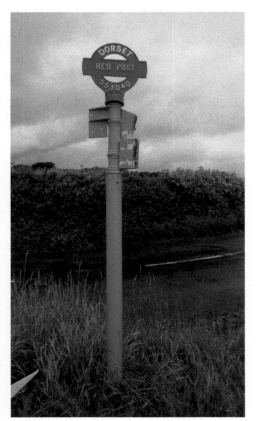

Above, left and opposite above: Dorset Red Posts.

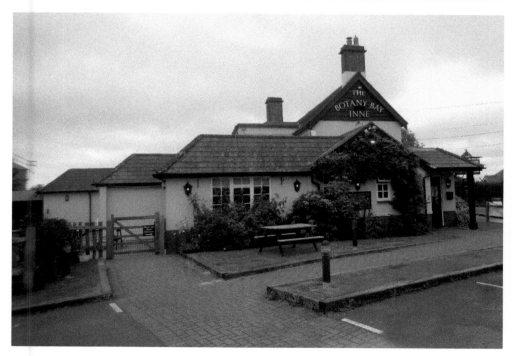

The Botany Bay Inne, Winterborne Zelston, Dorset.

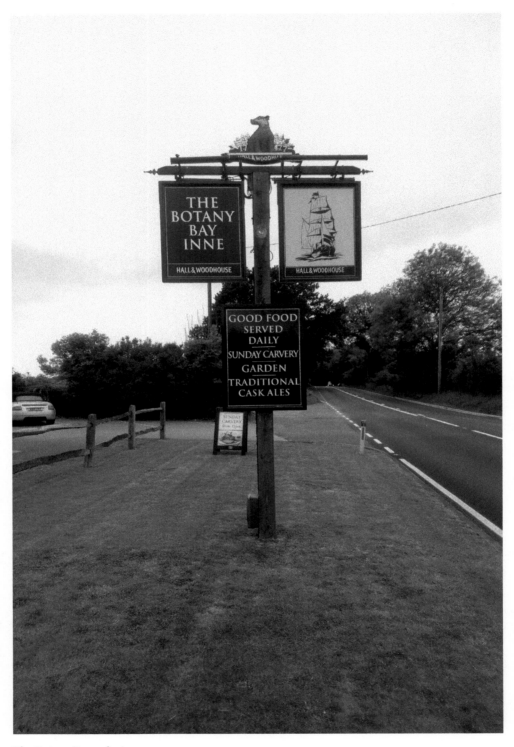

The Botany Bay pub sign.

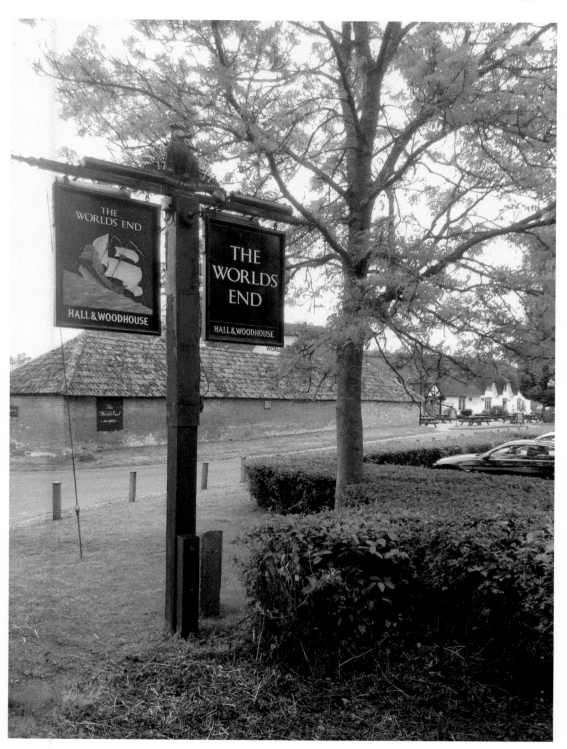

The World's End pub, Almer, Dorset.

Mary Blake, Teacher of the Maids of Taunton

The Taunton Maids were twenty-seven schoolgirls who had presented the Monmouth soldiers with flags in Monmouth's colours when they arrived in Taunton. Their teacher, Mary Blake, presented Monmouth with a sword and a bible. After the Bloody Assizes the maids were imprisoned until their parents paid a hefty ransom to save them from transportation. Mary Blake, who was also imprisoned, died in Dorchester gaol of smallpox.

The King Rewards Judge Jeffreys

Jeffreys was heard to boast that he had 'banged' more than all of the judges of England since William the Conqueror and by the time he had finished, just about every thoroughfare in the West Country was lined with body parts, ensuring that his terrible legacy remained for many years.

James II rewarded him for his sterling work with a promotion to the office of Lord Chancellor.

History lays the blame of the Bloody Assizes at the door of Judge Jeffreys, although in truth, James II should also take a large portion of the blame, as one could say that Jeffreys was merely enforcing the King's wishes and Jeffreys claimed that the punishments were not nearly brutal enough for the King.

The Effect of the Bloody Assizes

Having crushed the Monmouth Rebellion, James II was in a position to consolidate his power and restore Catholicism as England's premier religion.

Judge Jeffreys became James's henchman once more, and was President of the notorious Ecclesiastical Commission of 1686, which had jurisdiction over the governance of the Church of England, and was empowered to punish any offences under the act.

James's rule became increasingly tyrannical, but he was tolerated, as the public couldn't stomach further warfare after the Civil War and the Monmouth Rebellion. They knew that the next in line to the throne was James' Protestant daughter, Mary, and it was widely believed that James was ill and wouldn't last very long.

Everything changed when James' second wife, Mary of Modena, a Catholic like James, gave birth to a male Catholic heir to the throne, James Francis Edward Stuart, meaning there would be a long line of Catholic monarchs.

The brutality, severity and unfairness of the proceedings at the Bloody Assizes had shocked and antagonised the whole of the country. This allied to various moves by King James II to turn the nation into a kind of Catholic military dictatorship was beginning to cause widespread alarm.

Monmouth was seen as a noble martyr for the Protestant cause, and James's Protestant opponents planned once more to remove the King. In 1686, a meeting took place at Charborough House in Dorset, around 17 miles east of Dorchester, near Sturminster Marshall on the A31, hosted by Thomas Erle Drax who was the MP for Wareham and Deputy Lieutenant of Dorset. As a result of the meeting, seven leading statesmen and Protestant campaigners, including the Bishop of London, approached Mary, James II's Protestant daughter, to see if she was willing to take the throne in the event of her father being forced to abdicate. She agreed, on condition that her husband and cousin, William, would rule

alongside her as a joint monarch. This was considered to be a suitable option, as King William of Orange was the Stadtholder of the Netherlands and the grandson of Charles I.

William was more than happy to accept the invitation as he relished the opportunity of undermining the French Catholic King Louis XIV by preventing him forming an alliance with James II, and thus reducing the French threat to the Dutch.

Then in 1688, the next stage of the plan involved an influential group of ministers in Parliament drawing up a declaration of rights which accused James II of unconstitutional behaviour.

At the same time both William and Mary were invited to come to England from the Netherlands, and this was termed the Glorious Revolution – a kind of *coup d'état*. William landed at Brixham, Torbay, Devon, on 5 November 1688, with an army of Dutch and English soldiers.

Having seen from the Monmouth Rebellion that it was unwise to arrive with a small force and hope that the population would be able to rise up, he minimised that risk, and arrived with a substantial force of 30,000 troops, and such a large supply of equipment and supplies that it took two days to unload.

William's army then advanced to Sherborne Castle in Dorset, where he was entertained. He issued a proclamation, insisting that he came as a liberator not a conqueror. He was anxious that the coup would be popular and bloodless. Again this is what Monmouth wanted, but was unable to achieve.

William of Orange's army then advanced towards Salisbury, where on Salisbury Plain James II's army, under the command of John Churchill, pulled the proverbial rug from under the monarch's feet, by coming onto the side of William and Mary. This was the same John Churchill who was James's most experienced general, and had fought for James II against the Duke of Monmouth only three years earlier at the Battle of Sedgemoor.

James was left with no choice but to flee. He made a failed attempt to escape on 11 December, but finally fled to exile in France on 22 December 1688. Before he went, he threw Britain's Royal Seal into the Thames in petulance and disgust.

William and Mary, and Mary's sister Anne, who was intended as the Protestant heir, were then invited by Parliament to sign a Declaration of Rights which set out the personal and political rights of their subjects. The main points of the declaration were:

1. The monarchy should be Protestant.
2. A new Parliament should be formed regularly.
3. There should be no standing army without Parliamentary permission.

James II was the last Catholic monarch, and the long struggle between Crown and Parliament was over, as was the Divine Right of the Monarchy.

Judge Jeffreys was captured trying to flee to the Continent, and saw the last of his days out ignominiously in the Tower of London. It was unfortunate given his history that his passing away should be a natural death. However, his last four months were racked with pain due to his kidney stone, so some sort of natural justice did prevail.

So as we have seen Dorchester and Dorset played a pivotal point in the deposing of a king and the revival of the Protestant monarchy.

5. The Tolpuddle Martyrs

The Martyrs

George Loveless 1797–1874
James Loveless 1798–1873
Thomas Standfield 1790–1864
John Standfield 1812–98
James Brine 1813–1902
James Hammett 1811–1892

A series of enclosure acts initiated in the 1770s enabled landowners to fence off vast tracts of land in order to increase productivity. However, the acts also had the effect of increasing the poverty of the rural agricultural labourer, as it meant that they no longer had common land for grazing their own cows, sheep or pigs, causing their diet to deteriorate to a basic diet of tea, bread and potatoes.

By the time of the early nineteenth century, the prosperity of villages in the West Country had declined considerably and the Dorset labourer had became a byword for grinding poverty and degradation. The men that were to become the Tolpuddle Martyrs, as was the norm for farm labourers in the 1830s, were working long hours for starvation wages.

Coinciding with this period was the burgeoning religious movement of Methodism, which was instigated in 1729 by John and Charles Wesley. It was initially an evangelical movement of the Church of England and Wesley's doctrine that Jesus Christ died for all humanity and that salvation is available for all struck a chord with the working classes and was the first religion to emphasise the individual.

Most of the Martyrs to be were Methodists and they found solace in their religion. Indeed, both George Loveless and his brother James were respected lay preachers on the Weymouth circuit, as was Thomas Standfield.

In 1833, to add to their existing issues of barely being able to feed themselves and their families, their wages were cut from nine shillings to seven shillings a week. Facing the very real prospect of starvation, the group of farm labourers who subsequently became known as the Tolpuddle Martyrs met under a great sycamore tree, which is now more than 300 years old, to discuss their options. They decided to form a Friendly Society of Agricultural Labourers, which was in effect the first Trade Union and marked a turning point in British industrial history. Shortly afterwards they met again at Thomas Standfield's cottage where they swore an oath of secrecy and loyalty.

Unfortunately the landowner, Squire James Frampton, heard of their activities and having witnessed the French Revolution feared that this was the sort of thing that could

Tolpuddle Old Chapel. The former chapel was built in 1818 as a Methodist Chapel and Thomas Standfield and George Loveless were chapel trustees. It was used as a chapel until 1843 and thereafter was used for agricultural storage. It is a Grade II listed building.

 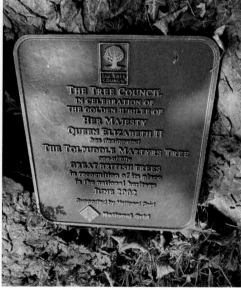

Above left: The Great Sycamore Tree under which the six farm labourers met in 1834 to defend their right to a living wage.

Above right: A plaque at the Great Sycamore Tree.

The green where the men met beneath the sycamore tree now has a Memorial Shelter.

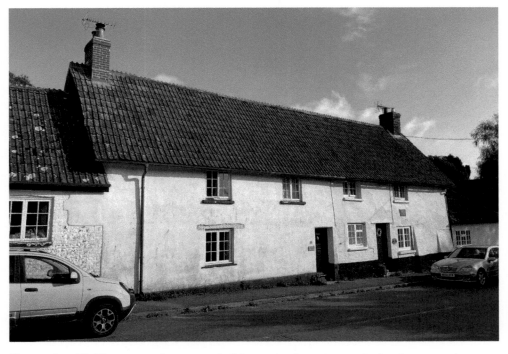

Thomas Standfield's cottage, where several of the martyrs' meetings took place in an upstairs room.

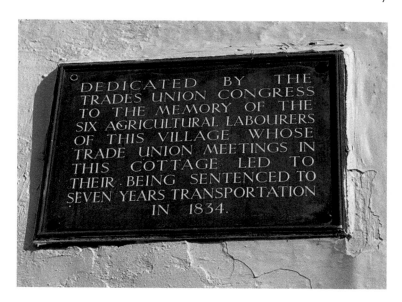

Commemorative
plaque on Thomas
Standfield's cottage.

threaten the natural order, so decided to make an example of the men. As well as being a
member of the local landed gentry, he was also a local magistrate and had influence with
the Home Secretary.

Lord Melbourne, the Home Secretary, was a ready ally of Lord Frampton in this matter,
as his view, like Frampton's, was that organised labour was a conspiracy against their
masters and he had previously been involved in quashing widespread agricultural unrest
during the Swing Revolt of December 1830.

The Swing Riots were widespread in the south, east and west of England and were a
response to the mechanisation of agriculture in the form of threshing machines, which
was driving wages and employment down. Rioters who were caught and processed
through the courts were either executed or transported.

Melbourne had advised Frampton to be sure that they had actually breached a law,
before he prosecuted them. Bearing this in mind, Frampton managed to establish that
although forming a trade union was in itself not against the law, making oaths of loyalty
and secrecy to each other contravened the Mutiny Act of 1797, an act which was intended
to prevent mutinies at sea.

On Monday 24 February 1839, George Loveless was visited by the parish constable
and informed that he and the others were required to attend court in Dorchester. They
voluntarily walked the 6 miles to Dorchester on the appointed day of 18 March 1834 for
their court appearance, believing that they had nothing to fear, as they had actually done
nothing apart from hold a couple of meetings. However, on arrival at the Shire Hall Court
Room in Dorchester, they were stripped, shaved and thrown into the cells, before their
trial.

George Loveless offered a dignified and articulate response to the charges against
himself and his colleagues when he wrote in his written statement, 'My Lord if we have
violated any law it is not done intentionally. We have injured no man's reputation,

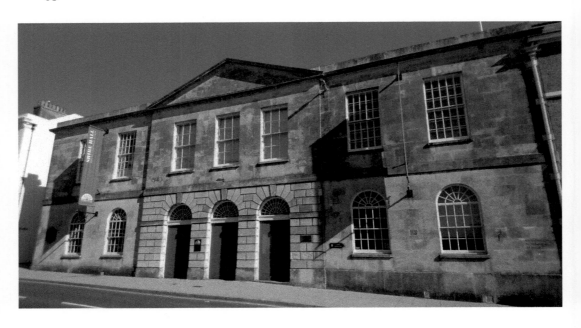

Above: The Shire Hall functioned as Dorchester's courtroom until 1955. It is a Grade I listed building that was built in 1797 and is now open as a museum.

Left: Distances to the nearest towns and beyond inscribed on the wall of the Shire Hall at a level for stagecoach passengers to read.

Below: A plaque in recognition of the Tolpuddle Martyrs on the wall of Shire Hall presented by the National Union of Agricultural Workers.

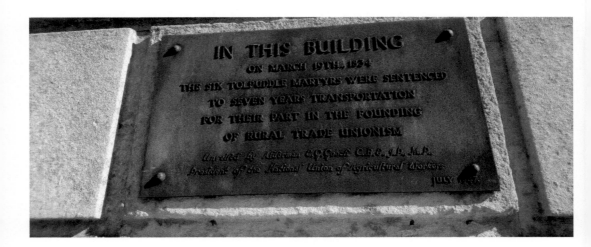

A mural dedicated to the Tolpuddle Martyrs to recognise the 150th anniversary.

character, person or property. We were uniting together to preserve ourselves, our wives and our children from utter degradation and starvation.'

The jury had been well and truly rigged; the foreman was William Ponsonby MP, brother-in-law of the Home Secretary, Lord Melbourne. Unbelievably the twelve men good and true also included James Frampton, the chief accuser; his son Henry; his step-brother, Charles Wollaston; and several local squires, who were also magistrates and had previously signed the arrest warrant.

The travesty of a trial was presided over by Judge Baron Williams and the six were duly found guilty of administering an oath and were given draconian sentences of seven years' hard labour in the penal colonies of Australia. The judge had discretion in his sentencing and could have ordered just seven days' punishment, but instead chose to impose the maximum penalty.

Five of the martyrs were shipped in the appalling conditions of the prison hulks to New South Wales, Australia, to begin their seven-year sentence as convict labour. George Loveless was initially too unwell to travel and so was dispatched later to Tasmania.

DID YOU KNOW?

Prison hulks were ships that had been condemned from every other type of use at sea. They usually consisted of three decks loaded with 500–600 prisoners who were secured to the decks with heavy irons attached to their legs.

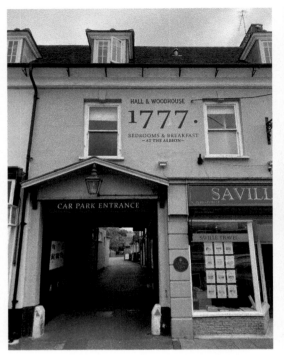 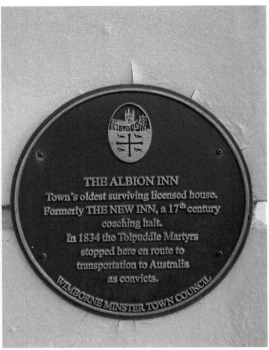

Above left: The Albion in Wimborne Minster where the Tolpuddle Martyrs stopped en route to transportation in Australia.

Above right: A plaque on the Albion.

The injustice resulted in a groundswell of public anger and protests, resulting in various social reformers and Members of Parliament taking up their case. Lord John Russell succeeded Melbourne as Home Secretary and was instrumental in finally persuading King William IV to secure their release.

Eventually in March 1836, having survived the horrors of virtual slavery in the colonies, they were given full pardons by the King. However, even then it took a while for news to reach the convicts, and it was some time before they made it back to England. James Hammett didn't get back until 1839, as he had been further convicted of an offence in Australia.

However when the men did eventually arrive back, they were feted as heroes and the London Dorchester Committee, which had been active in securing their release, had raised sufficient funds to set them all up to buy leases on farms in Essex. They stayed in Essex for a couple of years, but subsequently emigrated to Canada where they prospered. The exception was James Hammett, who remained in England and died in poverty in a Dorchester workhouse in 1891 aged seventy-nine. He is the only Martyr buried in Tolpuddle.

The legacy of the Tolpuddle Martyrs is the Trade Union movement, and an annual festival is held in Tolpuddle every July in recognition. There is also a monument in the Martyrs' honour in London, Ontario, where they emigrated to.

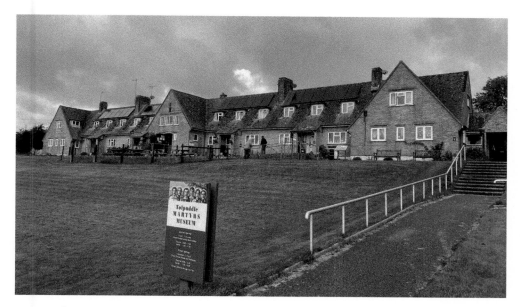

Memorial Cottages. The Memorial Cottages were built by the Trades Union Congress and were opened on 31 August 1934, the same year as the shelter was erected. They mark the centenary of the martyrs' transportation to Australia. The six houses were named in honour of each of the men and are intended for people who have served agricultural trade unionism.

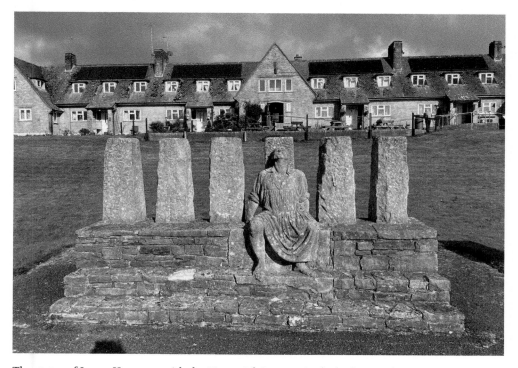

The statue of James Hammett with the Memorial Cottages in the background.

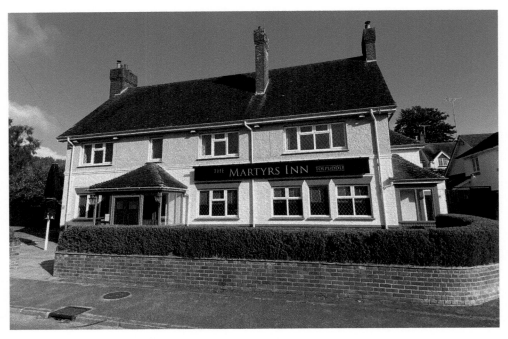

The Martyrs Inn. This pub was formally opened by Vic Feather, General Secretary of the TUC, on 21 September 1971.

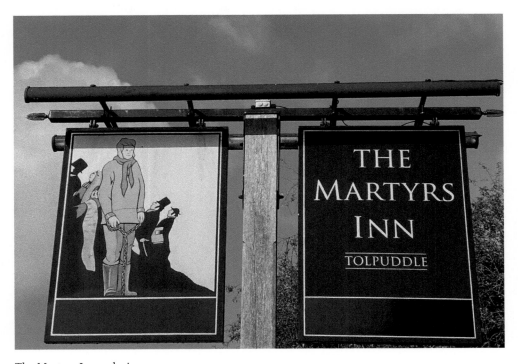

The Martyrs Inn pub sign.

Above left: James Hammett's grave.

Above right: James Hammett's grave is now commemorated by a headstone in Tolpuddle parish churchyard. It was presented by the TUC and dedicated in the centenary year of 1934.

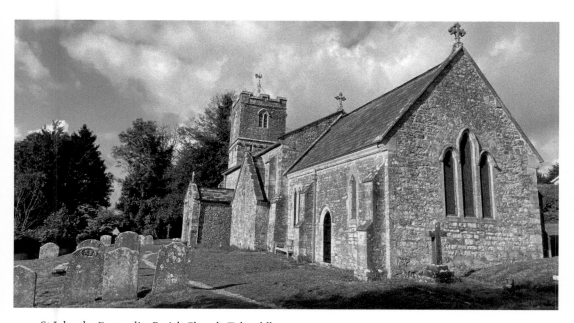

St John the Evangelist Parish Church, Tolpuddle.

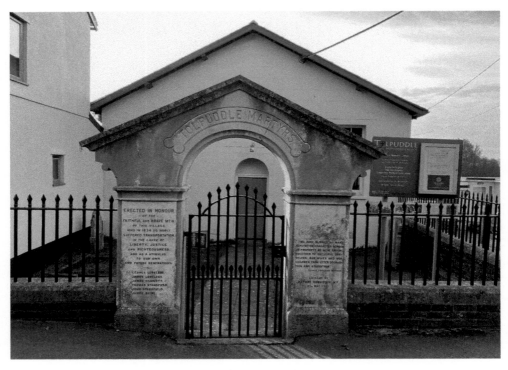

The memorial arch at the Methodist Chapel was dedicated in 1912.

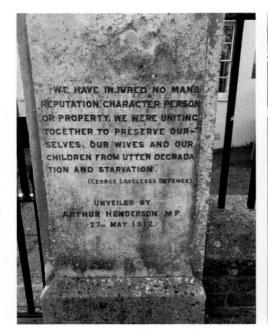

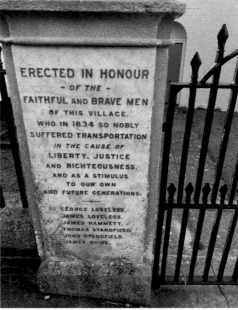

Above left and right: Inscription on the arch of the Methodist Chapel.

6. Thomas Hardy 1840–1928 – Casterbridge

Thomas Hardy, the famous poet and novelist, was born in Higher Bockhampton, on the edge of Thorncombe Woods, just 3 miles outside Dorchester, on 2 June 1840. The thatched cottage was built in 1801 by his great-grandfather who was a stonemason. His novels feature many aspects of Dorset life in the nineteenth century and it is said that much of his inspiration was drawn from playing in the countryside surrounding the cottage as a child.

Hardy was educated in the town and then at the age of sixteen became employed as an architect's apprentice working for John Hicks at No. 39 South Street, where a plaque recognising this can be seen today above the Gorge Cafe.

Hardy moved to London in 1862, where he studied architecture at King's College whilst also working on sites at St Pancras and Windsor. In 1870, he was sent by his firm to Cornwall to work on a restoration project of the parish church of St Juliot close to Beeny Cliff, near Boscastle. Whilst there he met and fell in love with Emma Gifford, who was the rector's sister-in-law and lived at the rectory.

They were married in 1874 and then had periods of living in both London and Dorset. However, the marriage rapidly went downhill and they rarely spoke to each other, causing

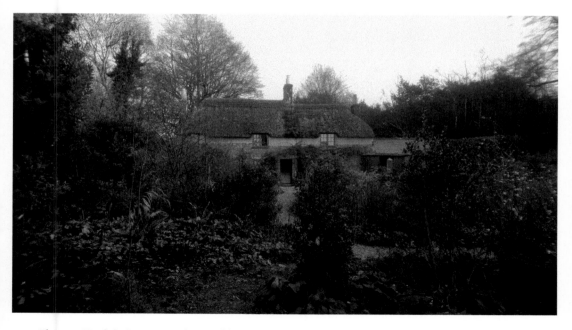

Thomas Hardy's Cottage, Higher Bockhampton.

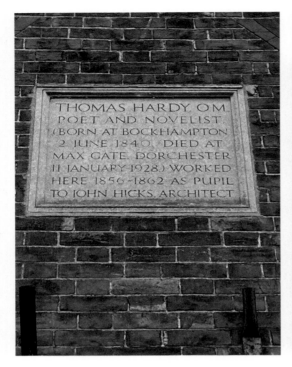

Above left: A plaque signifying the site where Hardy was employed as an architect's apprentice working for John Hicks at 39 South Street.

Above right: The former architect's office is now a fine establishment called the Gorge Cafe.

Hardy to seek solace in his writing, which he threw himself into. In 1885, they moved back to Dorchester, where they finally settled in a house that had been designed by Hardy and built by Hardy's brother, called Max Gate.

DID YOU KNOW?

Max Gate gets its name from Mack's Gate, an old toll house on the Wareham Road on the outskirts of Dorchester. The land was owned by the Duchy of Cornwall, but the future King Edward VII, who was then the Prince of Wales, had agreed to donate whatever piece of land Thomas Hardy chose to build his home on.

Hardy's first novel, *Desperate Remedies*, was published in 1871. He then had success with two further novels: *Under the Greenwood Tree* in 1872, followed by a *Pair of Blue Eyes* in 1873. Shortly after this he began to really cement his reputation as a brilliant writer when he produced his three famous classic novels: *Far from the*

Max Gate.

Madding Crowd (1874), *The Mayor of Casterbridge* (1886) and *Tess of the d'Urbervilles* (1891).

Hardy spent the majority of his life living in Dorchester and drew on that knowledge to write arguably his best and most famous novel, *The Mayor of Casterbridge*. Casterbridge is Hardy's name for Dorchester and the backdrop of the town provides plenty of recognisable settings. One such location is the King's Arms, which unusually for Hardy is referred to by its actual name. He was a regular patron and actually wrote large tracts of the book in a room upstairs which is now called the 'Casterbridge Room'.

The King's Arms is typical of an eighteenth-century market town coaching inn and it is described in the book as having a spacious bay window projecting into the street, which is exactly as it is now. He also brilliantly captured the atmosphere of the pub thus: 'The place was alive with the babble of voices, the jingle of glasses and the drawing of corks.'

Other locations that feature in the book are the Antelope Hotel, which is also mentioned by name (now Antelope Walk – *see* Monmouth Rebellion), Maumbury Rings, St Peter's Church, Grey's Bridge and the River Frome. A couple of other nineteenth-century customs that were common in Dorset, the Dorset Ooser and the Skimmity Ride, have also been preserved for posterity in the novel. The Dorset Ooser is a remnant from Pagan times and is a hideously frightening wooden mask replete with wild eyes, scary-looking teeth, a scraggly beard, facial hair and gigantic horns. The mouth usually had the ability to open and shut, enabling it to snap at people. The original ooser is thought to have represented the devil and featured in the novel as part of the skimmity ride.

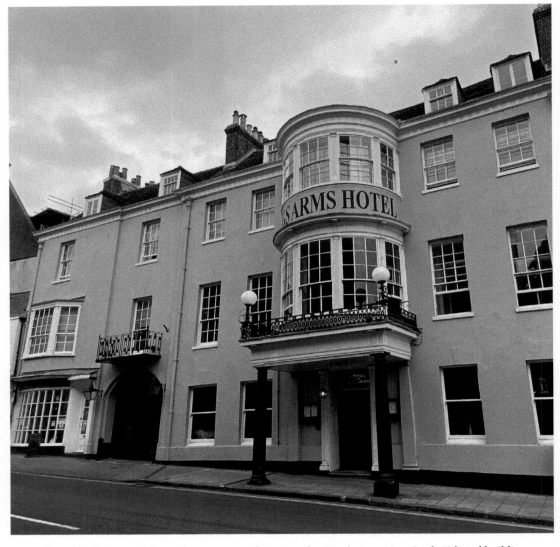

Above: The historic eighteenth-century coaching inn, the King's Arms, is a Grade II listed building which featured in *The Mayor of Casterbridge* and is where Hardy wrote large tracts of the book in what is now called the Casterbridge Room.

Opposite: The house in South Street that Hardy envisaged as the Mayor of Casterbridge's house is now Barclays Bank.

The Dorchester Museum houses a faithful replica of a Dorset Ooser, which is borrowed annually for the Morris dancing high jinks that take place in the nearby village of Cerne Abbas on May Day.

Aficionados of Thomas Hardy and *The Mayor of Casterbridge* in particular will be aware of the raucous and ludicrous procession of the skimmity ride and the scene

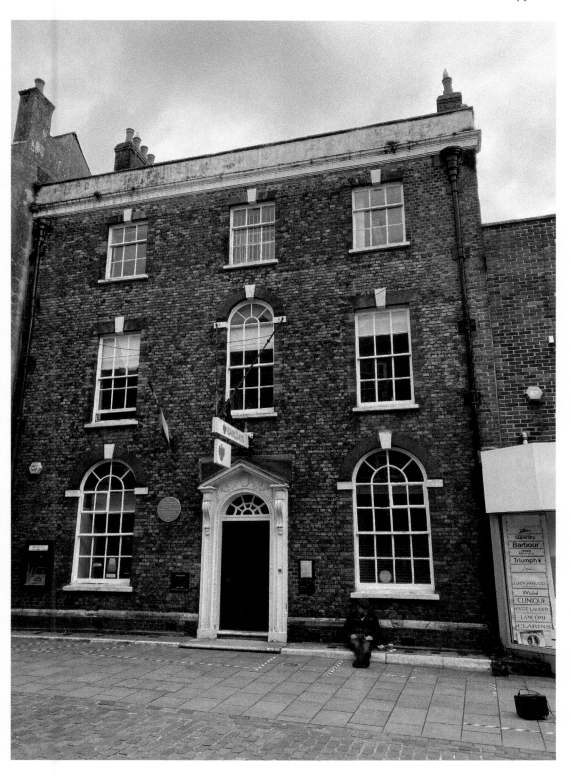

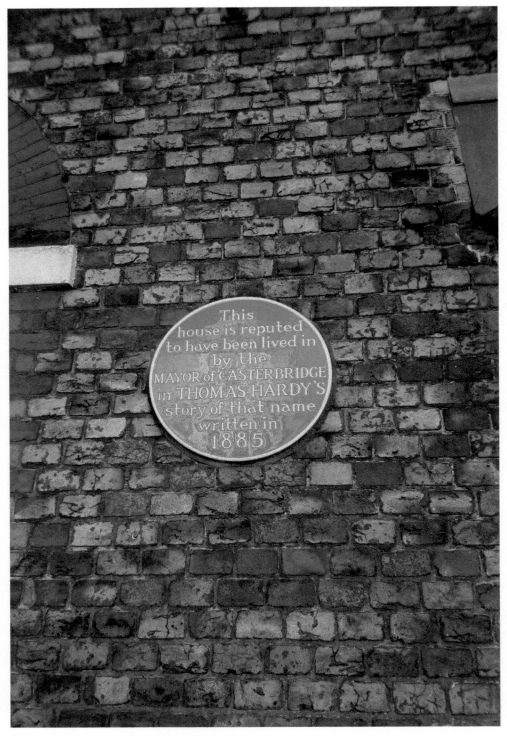

A plaque on the Mayor of Casterbridge's house.

when Lucetta dies from the shock of seeing a grotesque effigy of herself, paraded on a donkey, beneath her window while townsfolk are jeering and shouting abuse at her. The procession was intended to heap scorn upon a woman who had been unfaithful or mistreated her husband. The term 'skimmity' refers to a skimming ladle, which used to be known as the archetypal instrument a woman would beat her husband with, in the same way that a rolling pin would be associated with that nowadays.

Dorchester locations also feature strongly in his other classic novels. For instance, Dorchester Prison, the old workhouse and the Corn Exchange feature in *Far from the Madding Crowd*. Also, St John the Baptist Church in nearby Bere Regis houses the tombs of the local grand Turbeville family who were the d'Urbervilles in *Tess of the d'Urbervilles*.

Another influence for *Tess of the d'Urbervilles* was the court case of the servant girl Martha Brown that Hardy witnessed at the Shire Hall Court Rooms in 1856. She regularly suffered terrible abuse at the hands of her womanising, violent husband and when she found her husband cavorting in bed with another woman, a row ensued in which she was whipped by her spouse. Martha defended herself by striking him on the head numerous times with a pick axe. Her claim that he had been kicked to death by a horse was not believed and she was sentenced to death and was the last woman to be publicly hanged in Dorset.

A crowd of 3,000 witnessed the macabre spectacle outside the gates of Dorchester prison and Hardy himself climbed a tree close to the gallows to gain a grandstand view. The appalling scene made a lasting impression on the sixteen-year-old Hardy, who was ashamed that he had witnessed such an event. However, he drew on the experience in *Tess of the d'Urbervilles*, in his depiction of Tess, who was a pure but nevertheless fallen woman through no fault of her own; a dichotomy that was considered a scandalous contradiction at the time.

Hardy's description of Tess resembles how he had viewed Martha Brown as she hung on the gallows: 'What a fine figure she showed against the sky as she hung in the misty rain and how the tight black silk gown set off her shape as she wheeled half round and back.'

DID YOU KNOW
Hardy was a magistrate at Shire Hall from 1884 to 1919.

Despite his discomfort at witnessing Martha Brown's hanging, his macabre curiosity got the better of him a second time, when as he was eating breakfast at Bockhampton he remembered that a hanging was due to take place that day and hastened to the high ground of the heath to view the event through a telescope. He later recorded the strange sensation he had at the time, when he wrote that, 'He seemed alone on the heath with the hanged man and wished that he hadn't been so curious.'

In 1895, *Jude the Obscure* was published. Hardy's wife, Emma, was so shocked at the immoral content relating to religion, sex and marriage that she made an attempt

to prevent its publication. However, this was to no avail, which was unfortunate, as the book scandalised Victorian critics and the resultant reviews were so scathing that Hardy never wrote another novel again. Instead he concentrated on his first love, which had always been poetry and published his first collection in 1898 at the age of fifty-eight.

In 1908, he joined a local amateur dramatic group, at the time known as the Dorchester Dramatic and Debating Society, but later to become known as the Hardy Players. A plaque above Top Shop in South Street shows where they rehearsed and also makes mention of the Bugler sisters, Gertrude and Norrie.

Gertrude Bugler was the daughter of Augusta, who was a local milkmaid that Hardy was attracted to as a young man. He based the character Tess from *Tess of the d'Urbervilles* on her. Gertrude was very similar in appearance to her mother and Hardy cast her in the lead role in several dramatic adaptations of the tale. Her sister, Norrie, died at the age of 105 in 2011 and was the last of the Hardy Players.

A plaque above what is now Top Shop in South Street shows where the Dorchester Dramatic and Debating Society, but later to become known as the Hardy Players, rehearsed.

Hardy was made an Honorary Freeman of the town in 1910 and when he received the award he said, 'The freedom of the borough of Dorchester does seem to me, something I have possessed for a long while.'

Although the Hardys' marriage had not been a happy one, Emma's death in 1912 after thirty-eight years together left Hardy devastated. He was struck with regret as he remembered the happy times they had had whilst courting in Cornwall and reflected on why things changed when they were married and why they had stopped speaking to each other.

In 1914, he married Florence Dugdale, his secretary who was thirty-nine years younger than him. However, throughout his second marriage he continued to be troubled by his first unhappy marriage and Emma's death and found consolation in writing poetry. In later years he had an extremely aggressive and ill-tempered dog, a wire fox terrier called Wessex, whose grave can now be seen in the grounds of Max Gate.

DID YOU KNOW?

Max Gate finally acquired a bathroom in 1920, so at the age of eighty Hardy was able to have a bath in his own house at last.

In December 1927, Hardy became ill with pleurisy and he died at Max Gate on 11 January 1928.

Like many of his novels, there was a twist in the tale. The authorities at Westminster Abbey suggested he should be buried at Poets' Corner within the abbey. However, this created a dilemma as his wish was to be buried at Stinsford Church, not far from Higher Bockhampton, where he was born and where his family had worshipped for generations. His second wife, Florence, came up with the compromise that his ashes should be interred at Poets' Corner, as befitted his status, and his heart be buried at Stinsford Church near the rest of his family.

However, the plot is thickened further by the suggestion that when the local doctor removed Hardy's heart he left the room momentarily, to find upon his return a grinning cat and no heart left on the table. It is said that the doctor's solution to the problem was to strangle the cat and place it in the grave with Hardy's digested heart inside him.

A further piece of intrigue that has since come to light is a set of letters that reside in the Dorset History Centre which are correspondence between the Dean of Westminster and the Vicar of Fordington, the Revd Richard Grosvenor Bartlett. It seems that Hardy's burial in Poets' Corner was controversial as due to his novel *Jude the Obscure*, the Dean of Westminster had been inundated with complaints stating that Hardy was anti-Christian and that his moral standard was very poor. In response to this the Revd Grosvenor Bartlett countered that he was convinced of Hardy's basic Christianity, but that generally he refused to be drawn on religious matters.

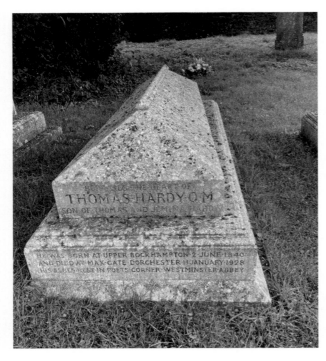

Left: Hardy's grave at St Michael's Church, Stinsford.

Below: St Michael's Church, Stinsford.

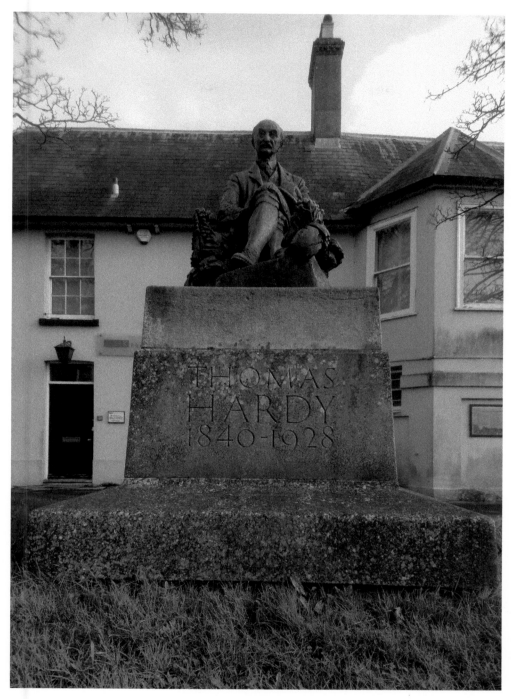

This statue of Thomas Hardy at the Top O Town is a Grade II listed structure and was sculpted by Eric Kennington. It was unveiled in 1931 by James Matthew Barrie, who was the author of *Peter Pan* and a friend of Hardy's. The statue is recognition of the esteem Hardy is held in in Dorchester, and the impact he had on Dorset.

7. Prisons, Hangings and Other Unpleasantness

The Prisons of Dorchester

In 1305, when the town received its royal charter, King Edward I confirmed the county's gaol would be in Dorchester and that was the case until 2014, when the prison closed its doors for the final time and the historic event was marked by a closing ceremony witnessed by hundreds of spectators.

Over the years, there have been five prisons, taking into account renovations on the same site.

1. Bottom of High East Street

The earliest gaol in Dorchester was in existence from 1305 and stood at the north end of Icen Way (then called Gaol Lane), where it joins High East Street.

A plaque denoting the former site of Dorchester Prison.

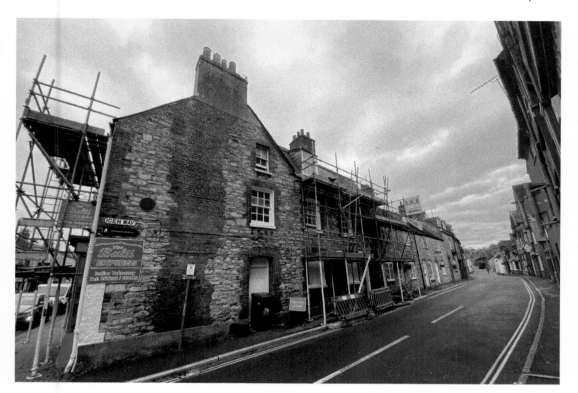

The former site of Dorchester Prison.

Of those that were sentenced to death, the lucky ones had to walk up to gallows hill and it is said that they were offered a last drink en route at The Old Bell Inn, a pub situated opposite what is now the Dinosaur Museum. However, the unlucky ones who were sentenced to be hanged, drawn and quartered were dragged there by their heels as they hung off the back of a cart, in the drawn part of that grisly demise (*see* Monmouth Rebellion).

2. Bottom of High East Street
Dorchester's second prison was built in 1633 and among those that died in this gaol were those from the Monmouth Rebellion of 1685. Some of the later prisoners in this gaol had things a little easier as at least the barbaric punishment of being hanged, drawn and quartered was abolished in 1780.

3. Bottom of High East Street
The third prison was also built on the same site and opened in 1784 but then only lasted until 1792.

4. North Square
The next prison was built in 1792 on a site that was occupied in Roman times and was also a medieval castle in 1154.

5. North Square

In 1877, the Prison Commission ordered the prison to be reconstructed as the building had deteriorated to a shocking state and the conditions that the prisoners were held in could be similarly described. The new and improved prison was built in the typical Victorian style.

This site was only closed in 2014, and before the closure it housed adult males convicted at Dorchester Crown Court and Bournemouth and Poole Crown Courts as well as from magistrates' courts throughout Dorset and some of Somerset.

Executions

The macabre spectacle of public executions were considered to be one of the best forms of spectator sport in days gone past and hangings would attract large crowds and generate a kind of carnival atmosphere as people amused themselves while they waited for the main event. There would always be plenty of drinking, fiddling and dancing taking place in what became known as Hang Fairs.

Up until 1836, hangings were often carried out for trivial offences like stealing sheep or cattle, but after that the death sentence tended to only be given for crimes of murder or attempted murder. By 1861, only four offences officially carried the death penalty: murder, high treason, arson in a royal dockyard and piracy.

The death penalty was abolished in 1965 in England, Scotland and Wales, but not until 1973 in Northern Ireland.

There have been four gallows locations in Dorchester.

1. Gallows Hill

Some of the More Interesting Executions at Gallows Hill

Gallows Hill was Dorchester's execution site in the sixteenth and seventeenth centuries and as we have seen, the victims were brought up from the gaol in Gaol Lane.

Roman Catholics in the Reign of Elizabeth I on the Charge of High Treason

In the reign of the Protestant Queen Elizabeth I (1558–1603), Catholics were persecuted and Catholic priests were executed.

Chideock was the main bastion of Catholicism in Dorset and Chideock Manor/Castle was owned by the Arundell family, who were devout Catholics and accordingly provided a refuge for priests and other followers to enable them to evade persecution.

In total, seven Chideock men including three priests and four laymen were executed in Dorchester for their faith between 1587 and 1642 and they became known as the Chideock Martyrs.

Hugh Green

The last martyr who died for his faith in Dorchester was Father Hugh Green, a Catholic priest who practiced at Chideock and was beatified by the Catholic Church.

On 8 March 1641, in the build-up to the English Civil War, King Charles I issued a proclamation banishing all Catholic priests from England in an attempt to placate the Puritan Parliament of England, who believed that the Church of England was becoming too Catholic.

Green was subsequently arrested in August of that year as he attempted to leave the country by boarding a ship at Lyme Regis. He was hanged, drawn and quartered by a very unskilled practitioner of the art and was brutally butchered in the process. Then to add insult to injury, Puritans played football with his head after his execution.

Dorset Martyrs Memorial

The Dorset Martyrs Memorial is a Grade II listed structure which was sculpted by Elizabeth Fink in 1986. It is situated on the site of the old town gallows at Gallows Hill. As can be seen from the photo, it comprises three bronze figures, two of which are naked facing a third figure who represents death.

It is a monument advocating the virtue of tolerance generally, but more specifically it represents the value of religious tolerance and especially commemorates those martyrs from Dorset who died here for their religious beliefs in the sixteenth and seventeenth centuries.

The Martyrs' Memorial is situated on a site formerly known as Gallows Hill, which was Dorchester's execution site in the sixteenth and seventeenth centuries until it was moved to Maumbury Rings around 1703. The words on the plaque read 'For Christ and Conscience sake' and were suggested by the Bishop of Salisbury.

2. Maumbury Rings

The gallows were moved to Maumbury Rings in around 1703 and were in use here until 1767. The most well-known execution at this site was actually a burning at the stake:

Mary Channing

In 1705, Mary Channing was only nineteen when she was accused of poisoning her elderly husband, thirteen weeks after she was cajoled into the marriage by her parents. She was pregnant at the time of the trial and the execution was delayed to allow her to give birth to her child. She protested her innocence, but it was to no avail, so she was burned at the stake in front of a crowd of 10,000 people.

Hardy makes mention of the case in *The Mayor of Casterbridge*, and his poem *The Mock Wife* is also inspired by this event.

3. The Gates of the Prison at North Square

From 1792, when the new prison at North Square was built, executions took place outside the prison gates. The timing of the hangings were delayed so that they were not before the arrival of the Royal Mail coach from London at the King's Arms, which was scheduled to arrive at 9.30 a.m. This was just in case the mail brought news of a late pardon. Crowds would gather early in the meadows on the other side of the river in order to ensure a good view and enjoy the Hang Fair.

Some of the More Interesting Executions at the Gates of North Square:

Martha Brown
(*see* Thomas Hardy).

DID YOU KNOW?

When Martha Brown was buried within the confines of Dorchester prison, a Roman floor mosaic was discovered. However the floor was not removed to the Dorchester museum until it was rediscovered two years later when James Seale was buried.

James Seale

James Seale was the last man to be hanged in public at Dorchester prison and the last man to be hanged in public in Dorset. He was hanged on 10 August 1858 for the murder of a woman called Sarah Guppy.

John's Pond

This pond gets its name from the legend of the only prisoner ever to escape from the North Square prison, named John. He made his exit via a well but then fell into the pond in the dark of the night and drowned. It is said that he haunts the local area.

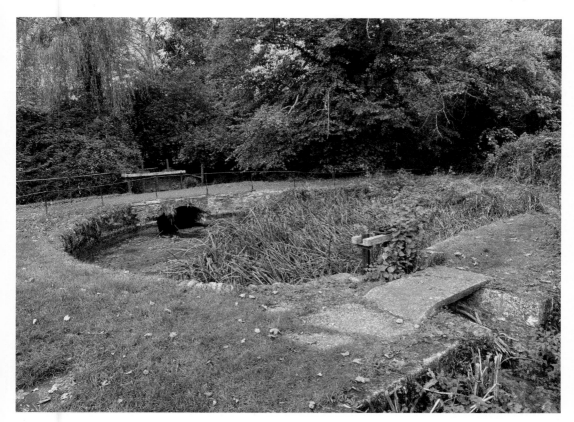

John's Pond.

The pond is part of the drainage system for the adjacent meadows and may have previously been used as a sheep dip.

4. Gallows Within the Walls of the Prison
Some of the more interesting executions from within the walls of the prison:

Jonah Detheridge
On August 12 1869, Jonah Detheridge was the first man to be executed within the walls of the prison at a site where spectators were not allowed to be present. He was from Wednesbury, Staffordshire, and as a prisoner at Portland prison formed part of a work party breaking stones at one of the quarries of Portland. His crime was beating the assistant warden, James Trevett, to death with his pick axe after he had been told to increase his work output.

David Jennings
Dorset's last hanging took place in 1941 and was the execution of David Jennings, a twenty-one-year old soldier. He had been part of the British Expeditionary Force that

was evacuated from Dunkirk, but in 1941 he found himself based in the barracks at Dorchester.

He had recently received a 'Dear John' letter from his fiancée and wasn't in the best of moods when he hit the town in a bid to drown his sorrows. Having consumed many pints and whisky chasers, his alcohol-addled mind influenced his plan of returning to the barracks to collect his rifle with the intention of stealing some money and deserting.

He broke into an office in Princess Street, where his attempts to open the safe by firing at it were unsuccessful. He then broke into the NAFFI canteen a few doors along, where he also tried unsuccessfully to unlock the safe by firing shots at it. He then went back into the street and when a door opened from the office building he had previously attempted to rob, he fired a shot and killed caretaker Albert Forbes.

Hangman's Cottage
The Hangman's Cottage in Glyde Path Road is a Grade II listed building and is a relic from a time when there were so many hangings that each town was required to provide its own hangman. After 1861, times changed a little and there were fewer offences that carried the death penalty, meaning there was only a requirement for one hangman for the entire country.

Hangman's Cottage. This cottage, as the name suggests, was formerly the home of the town's chief executioner.

Hardy spoke of his fascination with the cottage and recalled peering in and watching the hangman eat his breakfast before an execution. The cottage also features in a Hardy short story called the *Withered Arm*.

Transportation
Felons tended to be transported to the British American colonies until the War of American Independence (1776–83), whereafter they were transported to Australia instead. Transportation to Australia ceased in 1867.

Grey's Bridge
Grey's Bridge was built in the 1740s at the behest of the owner of Kingston Maurward, Mrs Laura Pitt (née Grey), who was married to the cousin of William Pitt, the former prime minister. The bridge bears a plaque which, like ten other bridges in Dorset, carries the threat of transportation to anybody who causes malicious damage to it.

Above: Grey's Bridge.

Right: A notice threatening transportation for anyone damaging the bridge.

Thomas Fooks, whose name is on the plaque, was a solicitor of Sherborne, Dorset, and was a Clerk of the Peace for Dorset. The purpose of the sign was to prevent damage that was occurring to bridges as a result of protests against agricultural mechanisation, which ultimately intensified to become the Swing Riots of 1830.

German Prisoner of War (POW) Camp

A First World War German prisoner of war camp was situated in Dorchester. The prisoners were initially interned in the buildings of the Royal Artillery Barracks, which is where the Grove Trading Estate now resides.

At first the internees consisted mostly of German civilians living in Britain who could potentially be a risk to national security. However, as the war progressed vast numbers captured from the front arrived to be imprisoned and a more permanent camp had to be established. Rows of huts were built, each with electric lighting and heating and containing thirty inmates. These were the lap of luxury compared to the guard's accommodation, which consisted of tents situated around the bleak Poundbury Hill Fort.

The POW camp became one of the largest in the country and held over 4,000 prisoners at its peak. The prisoners spent their days working on local farms, but in the evening various societies and clubs existed for them and entertainments were also laid on.

However, there were still some escape attempts, none of which were successful.

Only twelve men died in the camp, so the percentages of surviving were considerably higher than from being in the trenches.

The memorial in St George's churchyard, Fordington, was sculpted from Portland stone by a prisoner named Josef Walter and was designed by fellow prisoner Karl Bartholmay in 1919. The inscription is in German and means, 'Here lie German soldiers in a foreign land but not forgotten, 1914 – Dorchester – 1919.' It is the only freestanding war memorial to the German prisoners of war who were held in this country.

Bibliography

Books

Belasco, S., *Dorset from the Sea* (www.veloce.co.uk 2015)

Cotton, N., *Ordnance Survey Cycle Tours. 24 one-day routes in Dorset, Hampshire and Isle of Wight* (Hamlyn, 1993)

Cullingford, A. C. N., *History of Dorset* (Phillimore, 1984)

Draper, J., *Dorchester Past* (Phillimore, 2001)

Draper, J., *Dorset: The Complete Guide* (Dovecote Press, 1988)

Hilliam, D., *The Little Book of Dorset* (History Press, 2010)

Jackson, A., *Historic England: Dorset* (Amberley Publishing, 2020)

Jackson, A., *Poole Pubs* (Amberley Publishing, 2019)

Jenner, L., *The Monmouth Rebellion and the Battle of Sedgemoor* (Somerset County Council Heritage Service, 2017)

Page, M., *The Battle of Sedgemoor, Westonzoyland, Somerset* (FR Hist Soc.)

Potts, J., *Phillips Encyclopedia* (Octopus Publishing, 2004)

Power, M., Pub Walks in Dorset (Power Publications, 1989)

Tincet, J., *Sedgemoor 1685 Marlborough's First Victory* (Pen and Sword Military Publishing, 2005)

Whaley, P., *West Country History* (Venton, 1977)

50 Walks in Dorset (AA, 2009)

Information Boards

Abbotsbury village car park

Gallows Hill

Giant Inn

Monmouth Ash Pub, Verwood, Dorset

Roman Town House

Tolpuddle Martyrs Museum

Worlds End Pub, Almer, Dorset

Magazines

Allendale Magazine, Geoff Cobblestone, Oct–Dec 2021

Dorchester Heritage, Autumn 2021

Dorset Living– Local Landmark Reborn, August 2021

Dorset View, January 2022 Volume 19 Issue 6

The Oldie, Dorset's Last Stand Against the Romans, Patrick Barham, January 2022

Sapiens – Anthropology Magazine, Kerdiwan Cornelius, 8 July 2021

Websites

www.archaeologytravel.com
www.bankesarmshotel.co.uk
www.bournemouthecho.co.uk 20 Oct 13
www.brittainexpress.com
www.cerneabbasbrewery.com
www.cerneabbashistory.org
www.dorsetand around
www.dorsetaonb.org.uk
www.dorsetecho.co.uk 4 February 2021
www.dorsetlife.co.uk
www.dorsetlive.com
www.dsw.church
www.englishheritage.co.uk
www.historicengland.org.uk
www.localhistories.org
www.loquis.com
www.lovedorch.com
www. Megalithic.co.uk
www.resortdorset.com
www.sjorelinesummer2018charmouth.org
www.visitdorset.com
www.wessexresearch.co.uk